IMAGES
of Modern America

SESAME PLACE

IMAGES

of Modern America

SESAME PLACE

Guy Hutchinson and Chris Mercaldo
Foreword by Bob Caruso

ARCADIA
PUBLISHING

Copyright © 2015 by Guy Hutchinson and Chris Mercaldo
ISBN 978-1-4671-3382-1

Published by Arcadia Publishing
Charleston, South Carolina

Printed in the United States of America

Library of Congress Control Number: 2015934402

For all general information, please contact Arcadia Publishing:
Telephone 843-853-2070
Fax 843-853-0044
E-mail sales@arcadiapublishing.com
For customer service and orders:
Toll-Free 1-888-313-2665

Visit us on the Internet at www.arcadiapublishing.com

For our incredible families, friends, and anyone with a dream

CONTENTS

ACKNOWLEDGMENTS

This book would not exist without the support and assistance of Jenn Martin at Sesame Place (Vice President of marketing as of 2015); the photographs, stories, and editing contributions of the great Greg Hartley (Sesame Place employee from 1980 to 2011); and the great people at Arcadia Publishing, Sesame Place, Sesame Workshop, and SeaWorld Parks & Entertainment™. Lastly, we would like to thank Joan Ganz Cooney and Lloyd Morrisett, the creators of *Sesame Street*, and Jim Henson, the creator of much of the original content for *Sesame Street*, including the Muppets™ from *Sesame Street*, for pursuing the noble dream of providing education through entertainment for the children of the world.

Unless otherwise noted, all images appear courtesy of Sesame Place.

FOREWORD

In 1980, I made the trip from Delaware County to Langhorne, Bucks County, Pennsylvania, to interview for a human resources intern position with a new, innovative children's play park. A joint venture between Children's Television Workshop (CTW) and Busch Entertainment Corporation, the play park was designed to be an interactive learning experience for kids and their families—a place where they could crawl, climb, build, explore, and have fun together. The concept was intriguing and interesting, but I was prepared to spend another summer cutting lawns if I did not get the internship. Luckily for me, I got the position, and 35 years later, I look back and realize how significantly that summer job impacted my career and my life.

Working at Sesame Place has been an amazing experience. I have watched the park evolve from a small playland on 14 acres of land to an almost 60-acre theme park with wet and dry rides, character shows, a fantastic daily parade, and both Halloween and Christmas events. I have met many amazing people, from celebrities including Susan Sarandon, Bruce Willis, and Mark Wahlberg to the thousands of special needs families who visit the park as part of our long-term partnership with Variety–The Children's Charity. But most of all, I have had the pleasure of watching millions of guests smile as they came face-to-face with their favorite *Sesame Street* friends.

Sesame Place is special because it has so many "firsts" for families—a first roller coaster ride, the first time they brave a water slide . . . countless family memories have been made here. Sesame Place is truly one-of-a-kind because after 35 years, it remains the only theme park in the United States based entirely on *Sesame Street*. I'm proud and blessed to have been a part of this uniquely amazing concept from the beginning, and I look forward to a bright and furry future.

—Bob Caruso
Sesame Place Park President
2015

INTRODUCTION

Theme parks are, by their very nature, remarkable. They are designed to take people away from the grind of the day and transport them to a place focused on fun.

Yet even in this remarkable industry, Sesame Place stands out. It is a theme park in the truest sense of the definition. It is a place countless children have memories of and countless mothers and fathers have stories to tell about.

Sesame Place is uniquely aimed at the very young. The children who watched *Sesame Street* in the 1980s played there until they blossomed into teenagers and then adults. When they became parents, they returned with children of their own.

Perhaps this is what happened to you. You have fond memories of your time there as a child bouncing around on Rubber Duckie Pond and swimming through the ball crawl. You have a faded photograph of you in Ernie's Bathtub.

Occasionally you still thought about Sesame Place. It was hard to forget. You would see a commercial on television for the park. You read in the paper about the new attractions every season. You would pass the giant water tower adorned with Big Bird and Elmo as you drove down the highway to work. You would pass by a giant rubber duck as you headed to the mall to do your holiday shopping.

Then, maybe you returned to Sesame Place years later as a mother or father and were amazed at the changes the park had been through. It really has changed. In 1980, the park that opened was a small, three-acre play place. The goal was to be part playground, part educational center.

In the years since, the park has grown and grown. It is always expanding and changing, adding water rides and attractions, changing park entertainment, creating more dining options, introducing fun amusement rides, and even adding a roller coaster.

Today, Sesame Place is 14 acres and is so packed with attractions that it feels nearly twice that size. The park now stays open into the fall and winter to celebrate Halloween and Christmas. Almost everything that was at Sesame Place on opening day in 1980 has been replaced with something new and exciting.

How did we get here? Let us take a look.

One

1978–1980
FROM CONCEPT TO REALITY

An April 1978 entry from Jim Henson's collection of journal entries, called *The Red Book*, states "Sesame Street begins talking about Theme Park." Later that year, Jim Henson, Children's Television Workshop (CTW, now Sesame Workshop), and Busch Entertainment Corporation (now SeaWorld Parks & Entertainment™) would collectively begin the preliminary design work for what would become Sesame Place.

CTW and Busch Entertainment Corporation would bring many notable creative forces aboard their Sesame Place design team, including Eric McMillan and Milton Glaser.

Eric McMillan, considered the father of soft play, is a Canadian designer best known for his exhibitions and interactive play areas. His work at Ontario Place on the Children's Village play area in 1972 and Water Play area in 1973 helped cement his reputation as a great designer of these kinds of places. These two projects introduced the ball pit/ball crawl, net climb, punching bag forest, rubber band bounce, and many other types of children's interactive play elements. Many of those elements would also find their way into his design for Sesame Place, which included land, air, and water themes. These themes would be reflected in both the architecture and layout of the park.

Milton Glaser is an American graphic designer best known for his design of the stylized "I Love New York" (I ♥ NY) logo, DC Comics' bullet logo, the Brooklyn Brewery logo, a famous Bob Dylan poster, and cofounding *New York Magazine*. Glaser and his design firm, Milton Glaser, Inc., would go on to design the original iconic Big Bird logo for Sesame Place, the Sesame Place typeface, the street sign signage for each attraction at the park as well as other park signage, the housings for the computers in the computer gallery, and more.

Work between these parties began in earnest late in 1979, leaving only several months of necessary design and construction until opening day. The official ground-breaking ceremony for the park took place on June 27, 1979. Together, these creative and guiding forces would quickly go on to successfully create "The Playground of the Future."

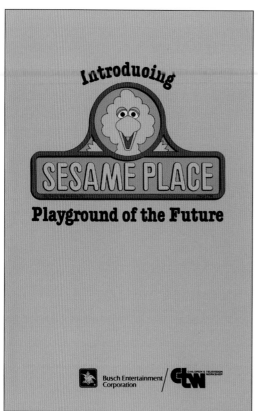

INTRODUCING SESAME PLACE. This brochure helped introduce the Sesame Place concept to the world. Front and center is the classic Milton Glaser–designed Sesame Place logo that can still be seen in some places around the park and was used for most of 1980–2013. (Courtesy of Milton Glaser Collection, Milton Glaser Design Study Center and Archives/School of Visual Arts Archives, Visual Arts Foundation.)

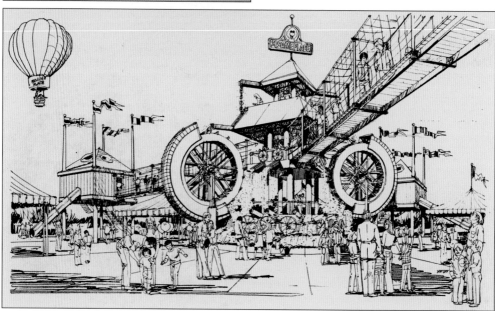

CONCEPT ART. This fine pen sketch shows a concept of the Sesame Water Tower and the Sesame Tube Slides. The end result at the park was very close to what was sketched here. Bert and Ernie fly overhead in a hot air balloon. (Courtesy of Milton Glaser Collection, Milton Glaser Design Study Center and Archives/School of Visual Arts Archives, Visual Arts Foundation.)

COMPUTER GALLERY DESIGN. The Computer Gallery featured Apple II computers in enclosures designed by Milton Glaser's design firm, Milton Glaser, Inc. The Pantone color codes are used by designers to ensure color correctness, in this case so they match the logo colors. (Courtesy of Milton Glaser Collection, Milton Glaser Design Study Center and Archives/School of Visual Arts Archives, Visual Arts Foundation.)

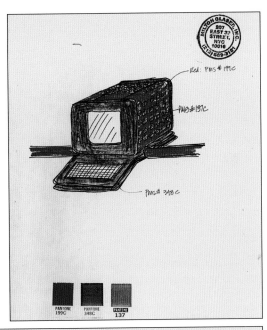

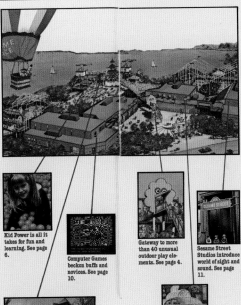

Sesame Place: 21st Century Playground

Sesame Place is a new idea in family entertainment: a total learning experience that blends wholesome physical activities, stimulating science experiments and challenging computer games.

The entire complex of outdoor play elements and indoor science activities and games offers youngsters from age 3 to 13, and their families, a futuristic playground where learning is fun. In fact, the play park has been described by the New York Times as a "21st Century playground."

The first of a projected series of parks, Sesame Place, Pa., is near the Oxford Valley Mall, just north of the intersection of U.S. 1 and I-95 between Philadelphia and Trenton, N.J.

Sesame Place is a three-dimensional extension of the learning-and-fun concept pioneered by the Children's Television Workshop (CTW), producer of such innovative educational television programs as The Electric Company, 3-2-1 CONTACT and, of course, Sesame Street, the internationally honored series that has delighted and taught millions of children around the world since its debut in 1969. Like all of these television shows, the new play park blends entertainment with education.

Sesame Place is a joint venture of CTW and Busch Entertainment Corp., developers and operators of two major theme parks: The Old Country, Busch Gardens in Williamsburg, Va., and The Dark Continent, Busch Gardens in Tampa, Fla.

Sesame Place is a completely active environment. Children and their parents supply the power for everything they do during their visit.

Youngsters can stretch their minds and bodies with innovative play elements and be joined by adults for many of the computer and science activities. An unusual restaurant offers its own special adventure—nutritious food prepared in an open kitchen where visitors can see the Sesame Food Factory "making good things taste good."

Sesame Street's beloved characters—Big Bird, Oscar, The Count, and the rest of their friends—are also very much in evidence throughout the park: as stars and guides in some computer games, as part of the general design motif, and in specially produced sketches appearing regularly each day on the park's closed-circuit television monitors.

A retail store, Mr. Hooper's Emporium, brings together for the first time, all the Sesame Street products under one roof, along with other educational and scientific playthings.

Sesame Place, while containing elements of a science museum, innovative playground and electronic game arcade, is a totally new concept.

Sesame Place is a totally *active* environment with strong educational overtones. Amusement and theme parks, on the other hand, usually offer *passive* experiences built around thrill and dark rides and shows. And where theme parks generally are large, occupying up to 300 acres and drawing from 20,000 to 80,000 visitors a day, Sesame Place is purposely small, taking up less than three acres and accommodating a fraction of the crowds drawn to a traditional theme park.

Moreover, Sesame Place is intended to appeal primarily to residents within its geographical region rather than to tourists. Hence the play park is designed for many visits of two to three hours each during the year rather than the longer but less frequent visits to a theme park. Finally, compared with a major amusement or theme park, Sesame Place is moderately priced—general admission is $3.95 plus tax.

Sesame Place is a major innovation in family entertainment. It is the first play park that meets the needs of families with preteen children with an attraction that is educational, participatory and located within less than an hour's drive of a market of five million people.

Kid Power is all it takes for fun and learning. See page 6.

Computer Games beckon buffs and novices. See page 10.

Gateway to more than 40 unusual outdoor play elements. See page 4.

Sesame Street Studios introduce world of sight and sound. See page 11.

For Schools, an exciting resource to enrich many subjects. See page 12.

Unique Restaurant makes good things taste good. See page 13.

21ST-CENTURY PLAYGROUND. Sesame Place was billed as the Playground of the 21st Century, and in many ways it was. This image is of a two–page spread that was a part of the "Announcing Sesame Place" brochure. It features both great concept art and real images. (Courtesy of Milton Glaser Collection, Milton Glaser Design Study Center and Archives/School of Visual Arts Archives, Visual Arts Foundation.)

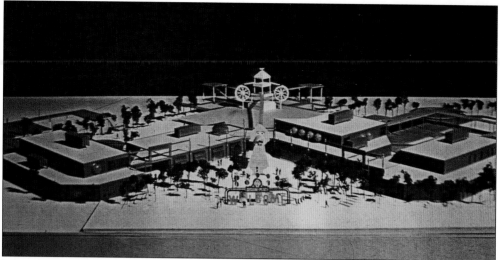

MILTON GLASER MODEL OF THE PARK. This highly detailed model is an overview of what the park would look like on opening day. The main gate arch, iconic Big Bird Bridge, and Sesame Place Water Tower with its spinning water wheels are all present here. The only item shown here that was not actually built are the letters at the front gate spelling out the word welcome. (Courtesy of Milton Glaser Collection, Milton Glaser Design Study Center and Archives/School of Visual Arts Archives, Visual Arts Foundation.)

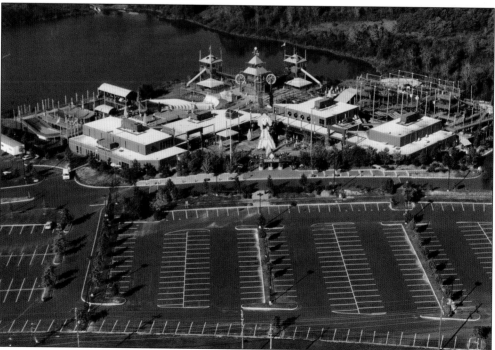

JUST LIKE THE MODEL, 1983. This 1983 aerial photograph shows just how close the finished park resembled the original model, even down to the blue-colored air conditioning units atop the buildings. The Big Bird Bridge entry, Big Bird's head, is where the center of the park and the Sunny Day Carousel is today. The park would soon grow out into the parking lot, with guests instead having to park across North Bucks Town Drive.

Two

1980–1984
Humble Beginnings

Langhorne, Pennsylvania, sounds like an unconventional choice of place to build a theme park, but nothing about Sesame Place was conventional. On opening day, there were no typical theme park attractions. The park was designed to encourage kids to be active and explore by themselves or alongside their parents. They could climb on nets, crawl through swimming pools full of plastic balls, jump on a giant air mattress, and soar over the ground on a cable glide.

Sesame Place also encouraged healthy eating with the Sesame Food Factory, developed by Joe Baum, who also designed the world-famous Four Seasons Restaurant and Windows on the World, which was located in the North Tower of the World Trade Center.

The Computer Gallery amazed guests by letting them interact with a personal computer. Today, multiple computers are present in most US homes. But in 1980, only about a million personal computers had been sold. Most visitors to Sesame Place were getting their first hands-on experience with a computer.

The park opened with an elaborate celebration. Big Bird was on hand to unveil the Big Bird Bridge as hundreds of balloons were released. Dignitaries and news officials traveled to Langhorne to be part of this new place to play and learn.

These early years of the park emphasized discovery, a time when the park was more of an exploratorium than theme park. Described by the *New York Times* as a "21st century playground," it was to be the first in a series of Sesame Place parks designed for short, frequent visits for three year olds to young teenagers.

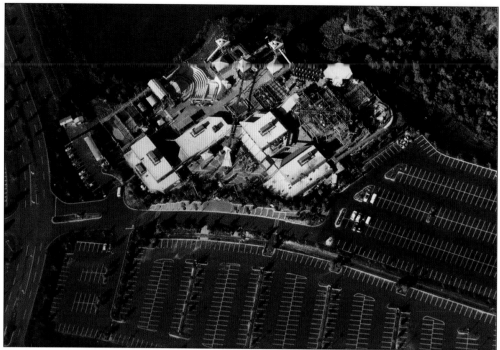

AERIAL VIEW, 1983. This aerial view of the park in 1983 shows many of the original opening day attractions and early park layout from above. In the center is the Big Bird Bridge head. The outer ring of the park, from left to right, features Super Grover's Cable Glide, Zoom Flume, Slippery Slopes, Sesame Tube Slide, Sesame Water Tower, Circle Theater, Ernie's Bed Bounce, and Herry's Hand Over Water.

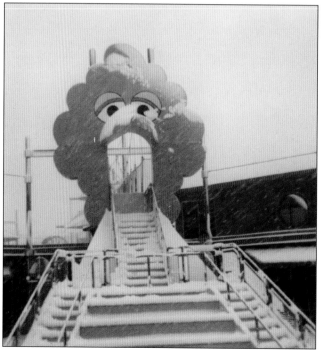

A THEME PARK IN THE NORTHEAST. One of the challenges in having a theme park in Langhorne, Pennsylvania, is the seasonal climate. Most popular theme park destinations are known for endless summer weather. Langhorne serves up the full gamut of spring, summer, fall, and winter. This Big Bird head served as the park's icon for many years, standing right behind the entrance during the first several years of operation. (Courtesy of Greg Hartley.)

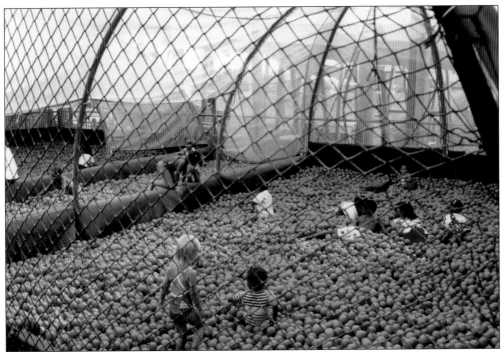

THE COUNT'S BALLROOM. Ball crawls are commonplace today, but in 1980, The Count's Ballroom was so popular a second ball crawl was added a year later. Guests loved crawling through 80,000 hollow plastic balls. Designer Eric McMillan said the idea came to him while daydreaming about crawling through a jar of pickled onions. As ball crawls became more common elsewhere, The Count's Ballroom became less popular, and both were removed by 2006.

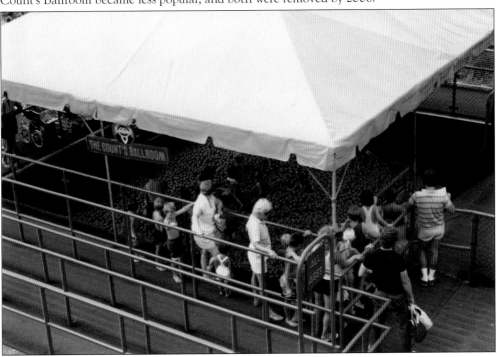

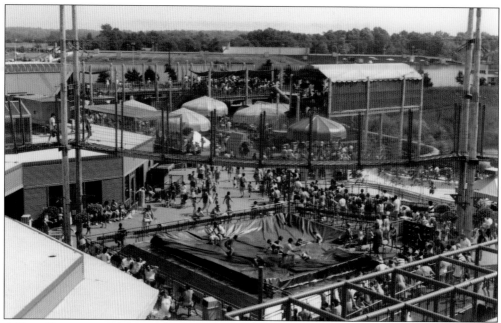

A BUSY DAY IN 1984. The green waterbed in the bottom center is the Rubber Duckie Pond, and overhead is Big Bird Bridge. In the center of the photograph are the silver structure of Rainbow Pyramid and the orange triangle of the short-lived Rolling Bin Spin. Toward the top is the queue for the orange Zoom Flume water slide, with the original light blue Slippery Slopes below it. (Courtesy of Greg Hartley.)

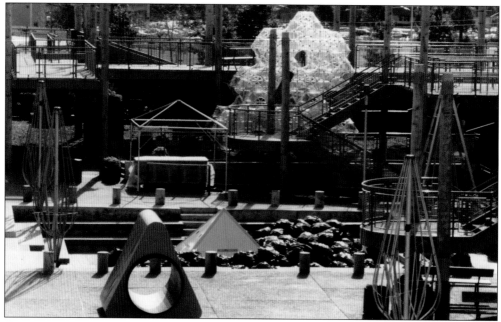

CLOSED FOR THE SEASON. Here we see the Rainbow Pyramid nearly covered by plastic bags storing the hollow plastic balls from the Count's Ballroom for the winter. In the distance we can see Crystal Climb. This popular climbing maze was later moved to the other side of the park near the Nets and Climbs. (Courtesy of Greg Hartley.)

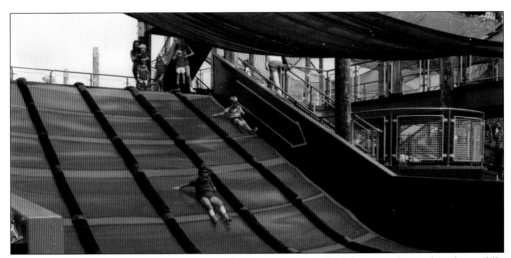

BRIGHT COLORS, BIG FUN. These slides, called the Sesame Slab Slides, were located in the middle layer of the Nets and Climbs structure. Part of Sesame Place's whimsy was its layered layout. Below the Sesame Slab Slides was Little Bird's Court, and up above the slides were the nets. The Sesame Slab Slides, often referred to as the Slab Slides, would stick around for two decades.

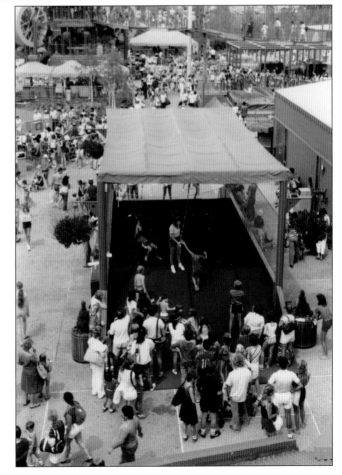

TWIDDLEBUG HOP. On a crowded 1984 day, people are lined up for a swing on Twiddlebug Hop. This was a fun and active attraction that was located behind The Computer Gallery until 1986. In the distance we see kids bouncing on Rubber Duckie Pond, wiggling through The Amazing Mumford's Water Maze, and traipsing across Big Bird Bridge. (Courtesy of Greg Hartley.)

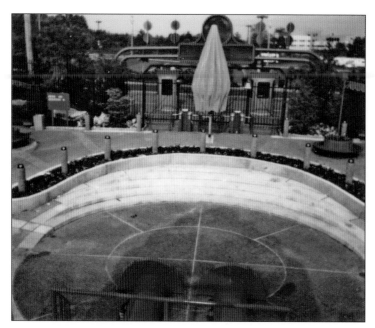

A Bird's-Eye View. Taken from the top of the Big Bird Steps, here is a look back at the entrance to the park. The sign at the gate was only single sided, and there were brightly colored yellow-and-orange ticket booths below. At the bottom of the steps were Big Bird's feet. The feet did not last long; they impeded traffic up Big Bird Bridge and were eventually removed. (Courtesy of Greg Hartley.)

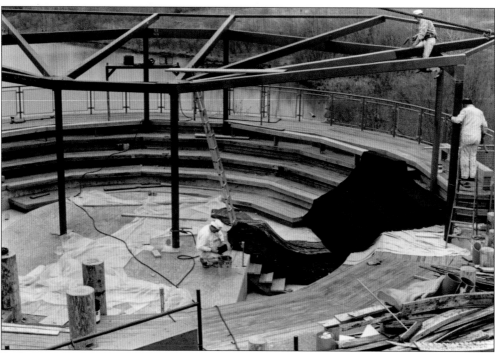

Constructing the Circle Theater. Here we see workers building the Circle Theater. This amphitheater was the first outdoor theater at Sesame Place. It opened with the 1983 season, replacing one of the two Ernie's Bed Bounce air mattresses. The Circle Theater was originally home to Ray Berwick's animal show. Ray was a well-regarded Hollywood animal trainer who had trained birds for *The Birdman of Alcatraz* and Alfred Hitchcock's *The Birds*. (Courtesy of Greg Hartley.)

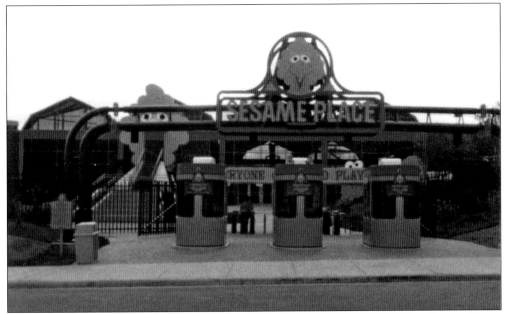

SESAME PLACE FOR THE LONE STAR STATE. A second Sesame Place opened in Irving, Texas, in 1982. Located near the Dallas/Fort Worth International Airport, the Texas park featured a different layout than its Pennsylvania counterpart but contained many of the same experiences. Unfortunately, the park did not receive the same success as Sesame Place Langhorne, and on January 11, 1985, it was announced it would close permanently. (Courtesy of Greg Hartley.)

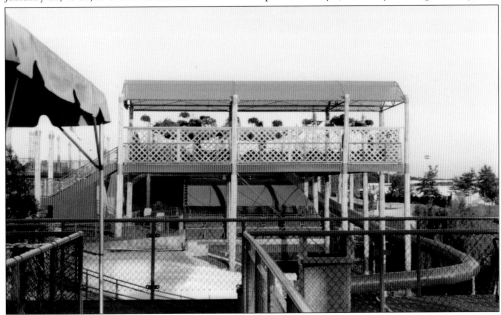

ADULT OASIS. The Adult Oasis was a canopied wooden patio built high above most of the play areas in the park. Here parents could relax in the shade, grab a drink at a juice bar, and still keep an eye on their little ones below. The orange slide is the Zoom Flume, a short-lived foam-lined steel water slide. A Zoom Flume slide was also featured at the Sesame Place in Irving, Texas. (Courtesy of Greg Hartley.)

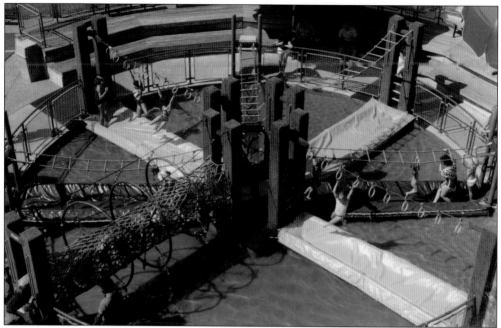

HERRY'S HAND OVER WATER. Named after the big, blue *Sesame Street* monster Herry, this play element featured a variety of familiar playground equipment combined in an ingenious way. Kids could swing from rings, hang from monkey bars, and crawl through tunnels over a pool of water. Herry's Hand Over Water was removed from the park by 1984, and today the area is part of Cookie's Monster Land and home to the Flying Cookie Jars. (Courtesy of Greg Hartley.)

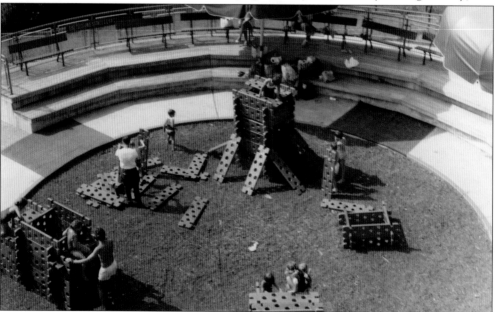

SESAME CONSTRUCTION COMPANY. The Sesame Construction Company was a play area where kids used oversized building blocks to create structures. It was easy to relocate and spent time in different spots during the park's early days. This 1984 photograph shows it in the spot of the removed Herry's Hand Over Water. (Courtesy of Greg Hartley.)

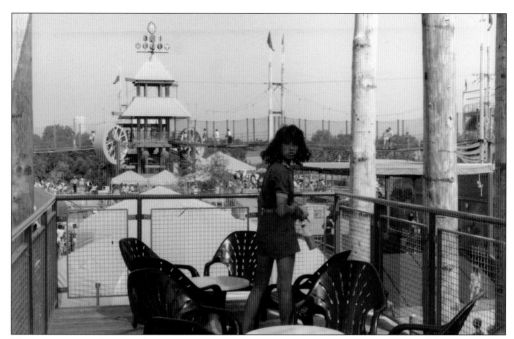

VIEW FROM THE ADULT OASIS. An employee cleans in the Adult Oasis, where grownups could enjoy impressive views of the park. To the right is Twiddlebug Hop, where children would grab a rope and swing from hill to hill. Straight ahead guests cross Big Bird Bridge into the 20-foot-tall Water Tower, where kids could pump and spray water. In the distance is the Middletown Township water tower, years before it got a Sesame makeover. (Courtesy of Greg Hartley.)

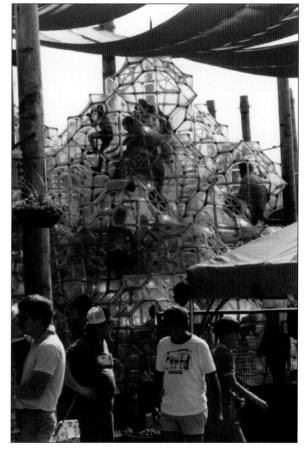

CRYSTAL CLIMB. The visually impressive Crystal Climb is full of climbers in this 1983 photograph. This popular geodesic climbing maze was unconventional and fascinating to look at from inside and out. A similar structure that guests could not climb was located outside of the Imagination Pavilion at Walt Disney World's Epcot Center. Sesame Place was essentially an Epcot for children, two years before Epcot opened. (Courtesy of Greg Hartley.)

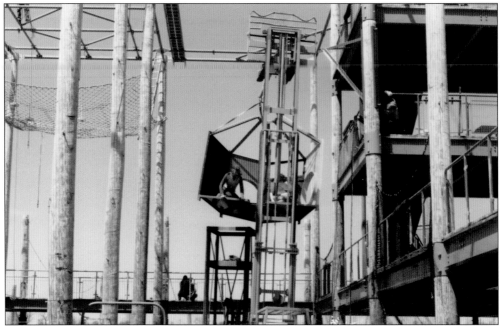

INSTALLING THE CROW'S NEST. The Crow's Nest is raised into place as the summit of the immensely popular Nets and Climbs. The giant cargo nets were popular from day one, but the Crow's Nest addition in 1983 created a finish line for the climb.

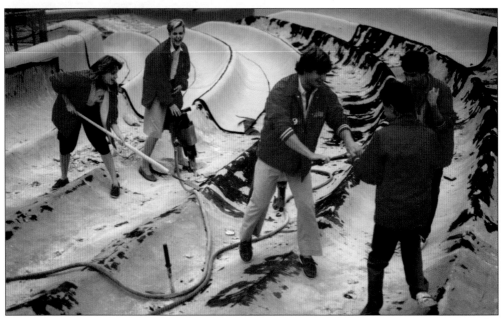

SLIPPERY SLOPES, TAKE TWO. The original Slippery Slopes featured foam-covered cement slides that curved. Sesame Place, an innovator in the water park industry, would replace this early water slide concept with a more modern fiberglass version that featured a double-dip drop into a splash pool. Here, the Sesame Place team pretends to deconstruct the original. (Courtesy of Greg Hartley.)

COOKIE MOUNTAIN AND BALANCING BUOYS. This 1980 photograph captures the red canvas material that covered Cookie Mountain in the early days of the park. The Count's Ballroom proved so popular during the opening season that ball crawl balls would be added to Cookie Mountain (and any other attraction they could work with) as well. In the background is a yellow Balancing Buoy on which guests could test their balance. (Courtesy of Greg Hartley.)

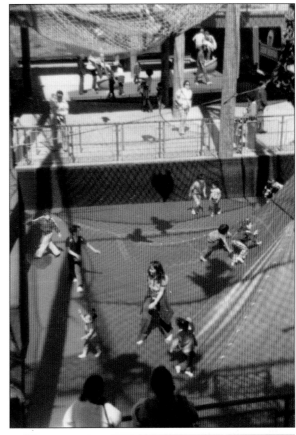

COOKIE MOUNTAIN TURNS BLUE. Cookie Mountain, a soft play climbing structure, would stay at the park all the way through the end of the 2013 season. Visible here is one of the park's original street sign attraction markers designed by Milton Glaser. The original red canvas was replaced with the Cookie Monster blue one pictured here.

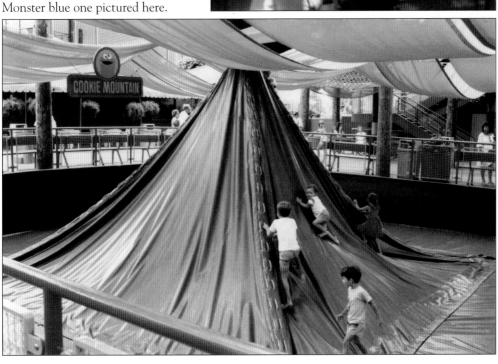

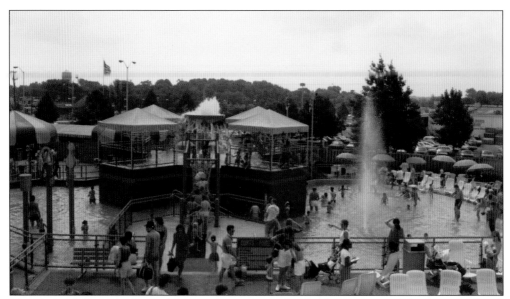

THE COUNT'S FOUNT. This early water play structure for children was one of the first of its kind. Guests in the lower wading pool below could climb a net to an upper level where a large (and loud) fountain constantly pivoted its overflowing water spout back and forth, spilling water onto those standing underneath it. The Count's Fount would be replaced with the more modern and sophisticated The Count's Splash Castle in 2009.

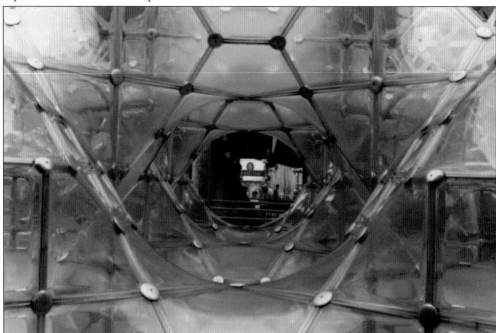

THROUGH THE CRYSTAL CLIMB. This is the perspective one would get entering Crystal Climb. The unique kaleidoscopic views are visible through the plastic. Directly ahead is the peak of Cookie Mountain and the signage for Big Bird's Court. Big Bird's Nest was the main feature of Big Bird's Court, but over the years it also hosted some additional experiences, including a relocated Grover's Rubber Band Bounce. (Courtesy of Greg Hartley.)

FLAG SYSTEM. In the early days of the park, Sesame Place lifeguards and slide operators used a series of flag signals to keep order and safety on the slides. The lifeguard at the top would wait for the lifeguard at the bottom to wave a flag signaling that the slide's run out was clear and ready for another guest to be sent safely down the slide. This lifeguard is sitting near the exit mouth of Zoom Flume. (Courtesy of Greg Hartley.)

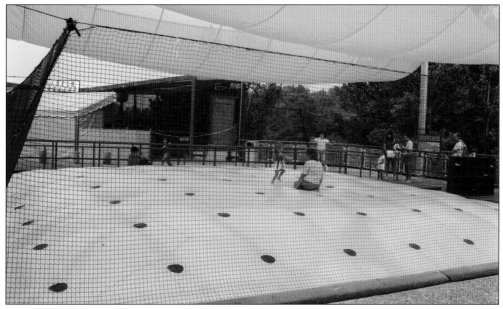

ERNIE'S BED BOUNCE. This giant inflatable mattress was another attraction that would last through the end of the 2013 season. Here, children and adults could bounce along safely on this giant bed-like structure. The attraction was so popular in 1980 that a second bed bounce was added in 1981 that lasted until 1983. The second Ernie's Bed Bounce was circular in shape.

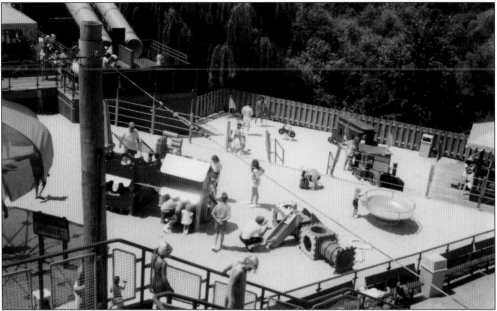

Little Bird's Court. Little Bird's Court was a play area for young children that featured several more off-the-shelf playground elements and play equipment in a sandbox-like area. In the background are two yellow slides called the Sesame Tube Slides that are dry sit-down slides still at the park today. They are now called Snuffy's Slides. The upper platform used to connect to Big Bird Bridge via the Sesame Place Water Tower.

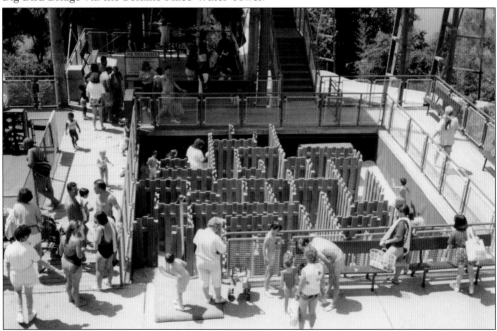

Oscar's Obstacle Course. Named after *Sesame Street*'s famous grouch, this twisty maze featured a sand bottom floor, wooden walls, and a fireman's pole to get participants into the obstacle course below. In the background behind the obstacle course are the stairs that led up to the top of The Big Slipper, now called Bert and Ernie's Slip and Slide.

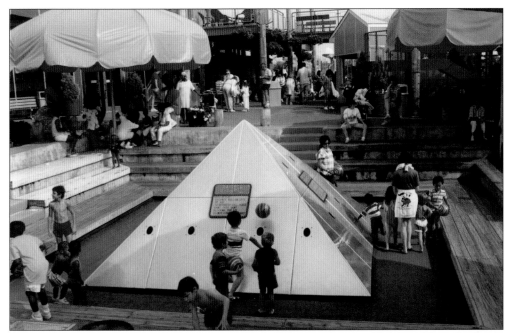

RAINBOW PYRAMID. This metal pyramid was one of two attractions in this area (the other being Snuffleballs) that demonstrated the wonders of air. The holes in the pyramid blasted jets of air upward, just enough air to balance a rainbow colored ball above it. Many children were fascinated by this great exhibit.

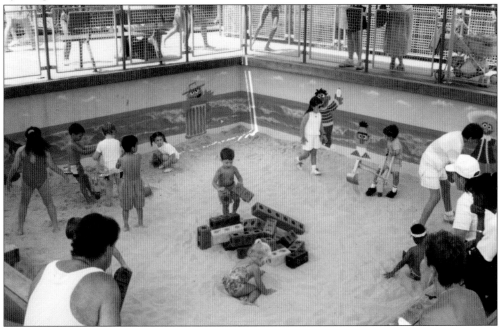

SESAME BEACH. Sesame Beach was a shaded sandbox with oversized building block bricks and playground steam shovels. *Sesame Street* characters alongside waves and sand were painted along the walls of the attraction to give it the feel of being at the beach. Today Sesame Place features a larger sand play area named Sand Castle Beach.

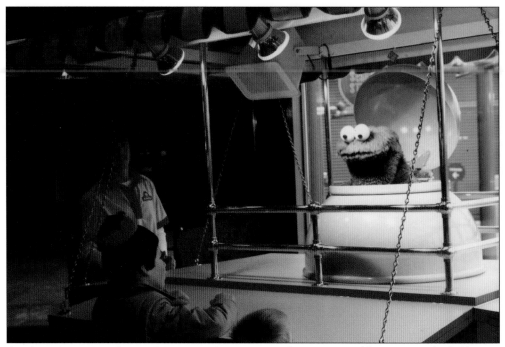

AN AUDIENCE WITH COOKIE MONSTER. Animatronic characters would interact with children at Sesame Place in the early days of the park. Here we see Cookie Monster emerging from a giant cookie jar to tell jokes, entertain, and educate park visitors. Another popular animatronic from the early days of the park was that of Oscar the Grouch.

FALL AT SESAME PLACE. While Sesame Place did not host an official Halloween event until 1997, here the steps of Big Bird Bridge are festively decorated for the season. To the far left is a large white dish called a Whisper Wall. Guests could speak into the center of the dish, and what was said could be heard at a sister dish several yards away. The Whisper Walls were relocated several times. (Courtesy of Greg Hartley.)

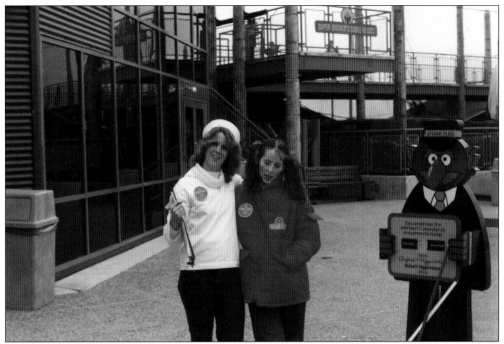

BUFORD T. HIGGENBOTTOM. Two employees stand near a standup of Buford T. Higgenbottom, an Anything Muppet. His image was on placards designating certain play elements as appropriate for people older than 13 or taller than five feet, two inches. Most play elements at the park were specifically designed exclusively for the younger and smaller set, hence Higgenbottom's designation of the other attractions as "Everybody Come & Play." (Courtesy of Greg Hartley.)

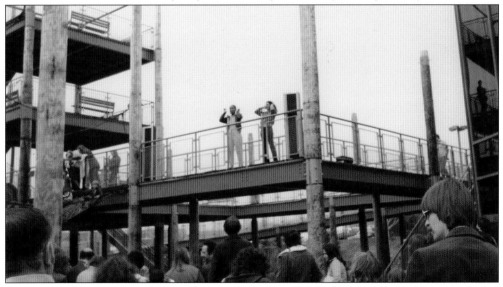

OLIVIA AND MARIA VISIT SESAME PLACE. Alaina Reed Hall (left) and Sonia Manzano (right) speak to guests from an elevated platform near the Nets and Climbs. Sonia has performed as Maria on *Sesame Street* since 1971 in addition to her Emmy-winning duties as a writer on the show. Alaina played Olivia from 1976 until she left the show in 1988 to pursue her acting career in Los Angeles. Alaina passed away in 2009 from breast cancer. (Courtesy of Greg Hartley.)

SCRAM! In addition to the animatronic Cookie Monster character, the park had an Oscar the Grouch who would tell jokes and sing songs recorded by puppeteer Caroll Spinney. Oscar's trash can was situated on a large cart surrounded by junk (including an old tire and a "Get Lost" sign). The cart had three walls that could close around Oscar to protect him from the elements when not in use. (Courtesy of Greg Hartley.)

GROVER'S RUBBER BAND BOUNCE. Grover's Rubber Band Bounce was a set of phone booth–sized enclosures that allowed children to bounce back and forth off of elastic walls. While no longer at the park, similar structures are still located at SeaWorld San Diego's *Sesame Street* Bay of Play®. Grover's Rubber Band Bounce would move several times before leaving the park. Visible in the background is the nearby Oxford Valley Mall. (Courtesy of Greg Hartley.)

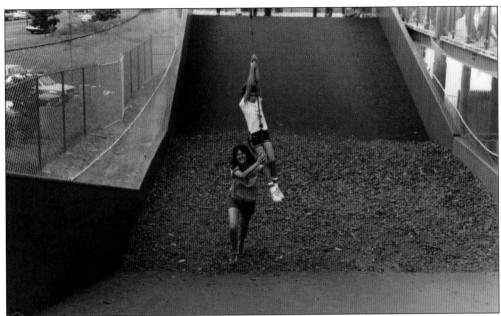

Super Grover's Cable Glide Jr.
A smiling employee gives a
child a push to get across the
valley between the sides of
this smaller version of Super
Grover's Cable Glide. The larger
cable glide was located on the
platform barely visible in the
top right of the photograph.
The cable glides were located
behind The Computer Gallery,
which today is Cookie's Cafe.

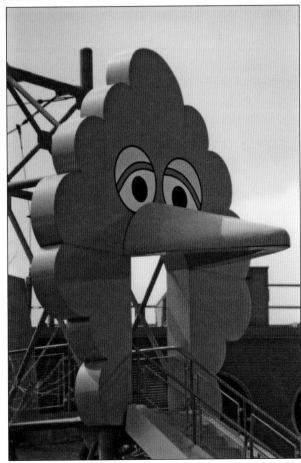

Enter through the Beak.
Big Bird's large head provided a
wonderful entranceway for children
as they walked up a flight of stairs
and onto the suspension bridge
that went above the park. As
the park expanded, the entrance
moved away from Big Bird's head,
and the bridge was removed. Big
Bird's head and steps became a
very popular spot for photographs.
It was eventually replaced with
the Sunny Day Carousel in 2008.
(Courtesy of Greg Hartley.)

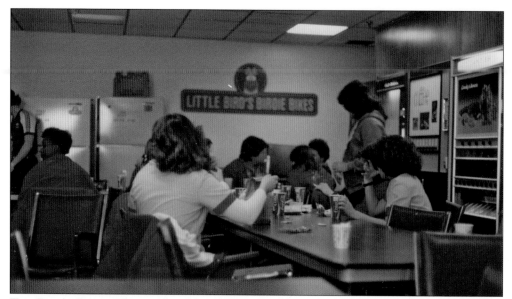

THE BREAK ROOM. The employee break room featured a sign made for a never-materialized attraction, Little Bird's Birdie Bikes. Little Bird was a counterpart to Big Bird, and his Birdie Bikes were intended to open with the park in 1980. Press materials explained that it would be a bicycle balanced on a cable 12 feet in the air that children could pedal a distance of 40 feet. (Courtesy of Greg Hartley.)

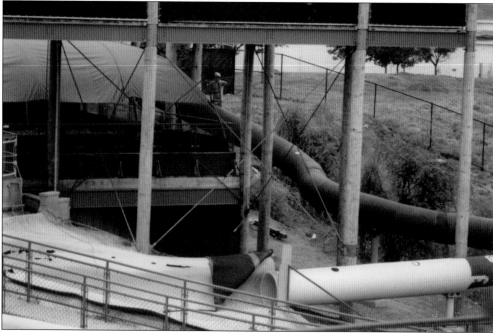

CONSTRUCTING THE ZOOM FLUME. Here we see the 1983 construction of the Zoom Flume. It was a single-person tube water slide that splashed down into a small pool next to one of the ball crawls. Zoom Flume was an exciting ride at Sesame Place, but with the additions of Runaway Rapids in 1984, The Big Slipper in 1985, and Sesame Streak in 1986, Zoom Flume was no longer needed and closed in 1986. (Courtesy of Greg Hartley.)

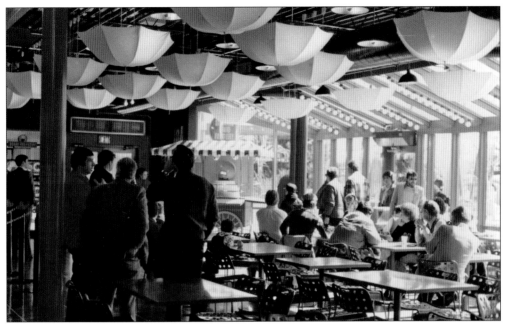

FOOD FACTORY. The animatronic Cookie Monster entertains some guests in the dining area of the Sesame Food Factory. The upside-down umbrellas on the ceiling provided a whimsical method of delivering soft light, and the ceiling pipes and ductwork were exposed. Exposed ceilings are commonplace today in big box stores, but in 1980 the concept was novel and gave park visitors a bit of an insight into how things work. (Courtesy of Greg Hartley.)

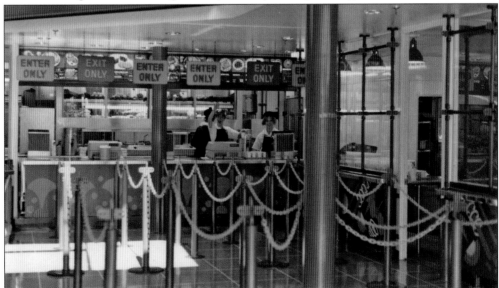

ENTER ONLY, EXIT ONLY. The Sesame Food Factory had a series of queues to make ordering food more organized. The restaurant featured large glass windows to allow diners a chance to see the workings of a restaurant. Behind the register were menu boards boasting healthy food options, including pastas and whole-grain pizzas. The pies were called "Square Meal Pizzas" because of their square shape and the fact they included 90 percent of a child's daily protein requirement. (Courtesy of Greg Hartley.)

BUILDING NEW MEMORIES. Due to the early success of the park, 1983 saw significant construction and improvements. Here we see large blue and orange pieces of the Twiddlebug Tunnel and the green and orange booths of Grover's Rubber Band Bounce ready to be assembled as the park gets ready for its 1984 season. (Courtesy of Greg Hartley.)

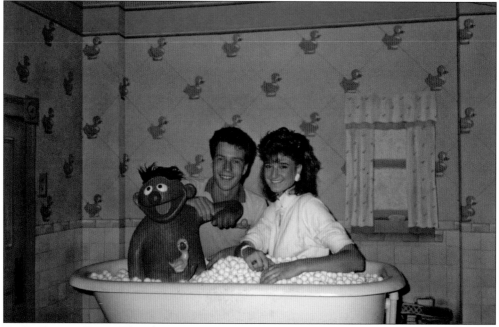

DO DE RUBBER DUCK. This photo opportunity with Ernie in the bathtub with his famous Rubber Duckie proved to be one of the most photographed spots in all of Sesame Place. Located inside of the Sesame Studio, guests could have professional photographs taken inside the tub as a souvenir. (Courtesy of Greg Hartley.)

Three

1985–1992
Water Expansion

As the park celebrated its fifth year, the focus of all new development began to shift toward the introduction of water attractions. At the time, water slides and the concept of a water park were new, with parks like Action Park in Mount Vernon, New Jersey, leading the way with the addition of extreme water slides.

Sesame Place's sister park in Irving, Texas, closed permanently in 1985 after only three years. Many of those park's elements were scrapped, but several made their way from the Lone Star State to Bucks County. Among those items is the main entrance gate, which guests now walk under while making their way from the parking lot to the park, as well as the Grover Clock, which is the clock outside the Monster Rock Theater.

The new water attractions added during this era included The Count's Fount, The Big Slipper, Slippery Slopes, and Sesame Streak, many of which still thrill guests at the park today.

In 1986, the beloved mascot of the park, Big Bird, finally made his debut as a walk-around costumed character, joining Ernie, Bert, and the Honkers, who had debuted three years earlier. Two years later, Grover and Prairie Dawn would join the growing cast of characters.

Also during this era, the park expanded into the original parking lot area that was located right in front of the Big Bird Bridge gateway. The new entrance was moved to the left side of the park, giving Sesame Place some much needed room for expansion as well as creating a whole new vista for park guests to see and explore with the addition of Sesame Neighborhood in 1988.

Highlighted in this section are some of the opening day attractions that stuck around through the early 1990s, including Sesame Studio and The Computer Gallery, the water slide and water play structure additions, the park's expansion, and some of the park's early entertainment and popular entertainment groups.

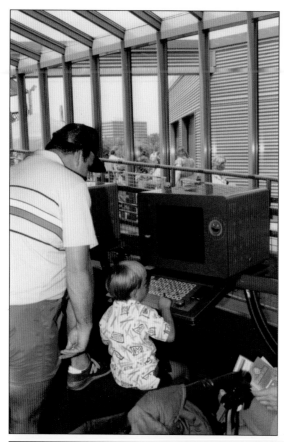

COMPUTER GALLERY. The Computer Gallery featured dozens of Apple II computers that children and adults could play and learn on together. The first time that many people in the Northeast experienced using a computer was at Sesame Place. Guests could put a token in a slot and then use a computer for several minutes, playing games such as Muppet Quiz and Mix-and-Match Muppets. Milton Glaser designed the computer housings.

LIGHT WAVES AND SCIENCE DISCOVERY. This photograph shows two large pin screens where thousands of pins would slide in and out independently. Kids could make an impression with their hand that would instantly disappear as gravity made the pins reset. Behind them a guest is looking at "Everyone Is You and Me." This science element consisted of a two-way mirror. Guests could adjust the amount of light and merge their reflection with others.

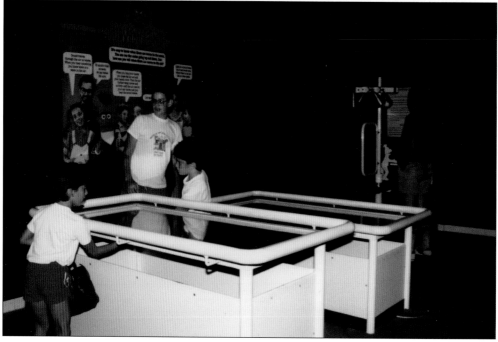

Shadow Room. The Shadow Room was a science element where children stood in front of a wall. After a flash of light, they would turn and see shadows remaining on the wall for a few seconds before fading. A phosphorescent wall was the secret. Essentially it was a wall of glow-in-the-dark material that allowed it to illuminate after the flash, except for the shadows of those blocking the flash.

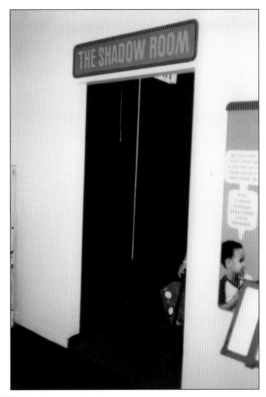

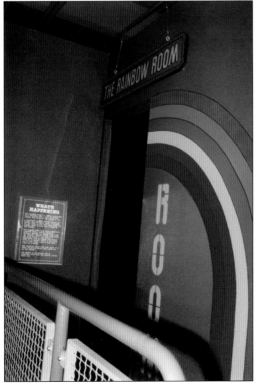

Rainbow Room. This room, along with the Shadow Room, provided guests with a unique experience. In the Rainbow Room, a computer and a video projection system worked in tandem to project a multicolored image of the guest on a screen. As the guest moved, so did his or her multi-colored image and shape.

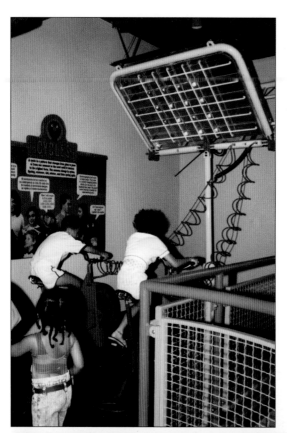

PEDAL POWER AND CYCLES. This interactive exhibit was located inside Sesame Studio and served as another science discovery activity that showcased the wonders of light. Children and adults could physically light the red and green neon lights and light bulbs by pedaling the stationary bicycle. The faster the guest pedaled, the brighter the bulbs would glow. On the left is an educational board that described how many things in the world work in cycles.

CREATE A MUPPET SHOW. One of the many unique interactive exhibits inside Sesame Studio was this Create a Muppet Show. In the earlier years of the park, guests could puppeteer and provide the voices of one of these three Anything Muppets. They could watch their live performance on a television monitor nearby. In later years, the Anything Muppets were replaced with food-themed rubber molded puppets, two pies, and a salad.

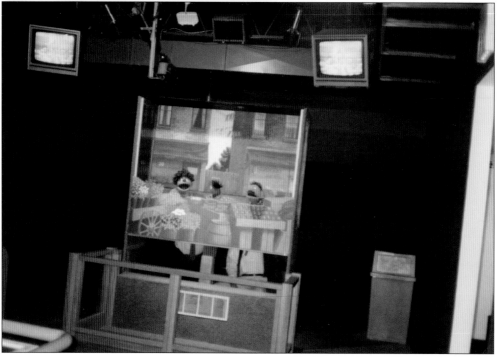

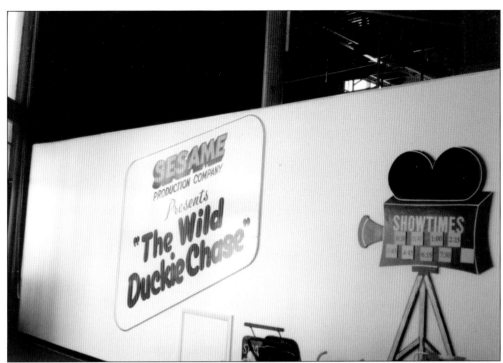

SESAME PRODUCTION COMPANY PRESENTS. Sesame Studio was originally a place where imagination and technology could meet. Here we see the colorful signage for the show *The Wild Duckie Chase*, a show that relied on blue screens to put children into the action. In 1997, Sesame Studio replaced that show with *The Amazing Adventures of Elmo and Zoe*, which featured a new green screen set.

THE WILD DUCKIE CHASE. This stage show inside Sesame Studio used members of the audience and had them act out what seemed like ridiculous scenes in front of blue screens. At the end of the show, all of the blue screen footage was edited together to include prerecorded footage with the Muppets of *Sesame Street* looking for Ernie's lost Rubber Duckie. It would entertain guests from 1989 through 1997.

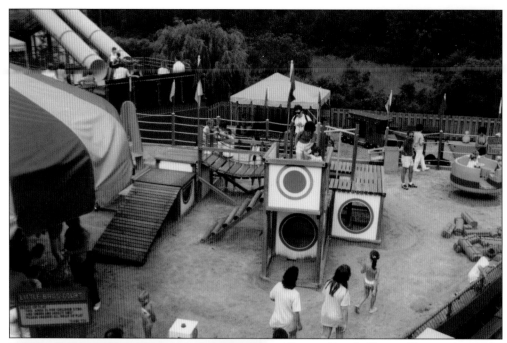

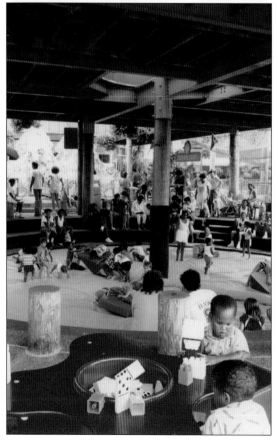

LITTLE BIRD'S COURT. During the 1980s, a character named Little Bird was often seen on *Sesame Street* as a counterpart to Big Bird. At Sesame Place, Big Bird had a giant head and bridge at the entrance of the park, and Little Bird had this play area at the back of the park. Here preschool-age children had a variety of ways to play. (Courtesy of Greg Hartley.)

BIG BIRD'S COURT AND CRYSTAL CLIMB. In the foreground is Big Bird's Court, full of preschool play activities. This soft play area featured play blocks, foam shapes, and more. In the background is the unique Crystal Climb play structure, a geodesic climbing maze that opened in 1982. As children climbed around the inside, the walls gave a kaleidoscopic view of the surrounding area.

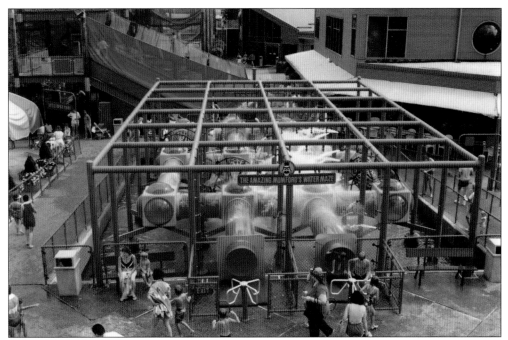

THE AMAZING MUMFORD'S WATER MAZE. This maze of tubes, net tunnels, and water sprays was named for the Amazing Mumford, a Muppet magician performed by Jerry Nelson. This attraction had the longest name and attraction street sign at the park. The background of this photograph also shows the many levels and layers of the park, with Little Bird's Court, Sesame Slides, and Nets and Climbs each occupying a different level.

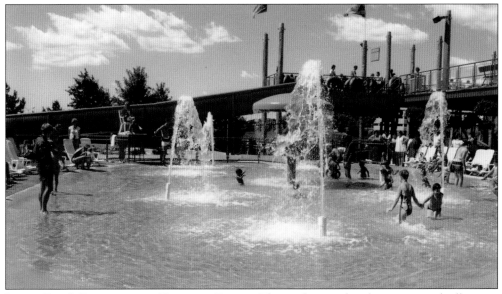

LITTLE BIRD'S BIRDBATH AND RUNAWAY RAPIDS. This wading pool with its water umbrella was a favorite of small children for decades. Its shallow depths acted as a pond for its namesake character. In the background is Runaway Rapids, a thrilling tube slide that began its adventure off of the upper deck pictured here before spilling into a concrete channel in the grassy forested area below full of twists, turns, tunnels, and bumps, which simulated rapids.

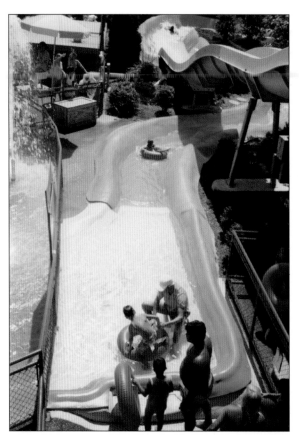

RUBBER DUCKIE RAPIDS AND RUNAWAY RAPIDS. Once again showing the many layers of Sesame Place, Rubber Duckie Rapids, described in the 1995 park map as "a shallow rippling water inner tube ride for preschoolers," runs underneath the starting double-dip drop of the more intense and thrilling Runaway Rapids. Both attractions ran through concrete troughs in the woods before spilling into an exit pool near the lake.

RUNAWAY RAPIDS. Added to the park in 1984, Runaway Rapids was the bigger, faster, bumpier, and more intense version of Rubber Duckie Rapids. Shown here are several guests (one having already spun backward) experiencing its rushing turns and about to enter its cyclone turnaround and tunnel that would spill into the attraction's bumpy rapids finale.

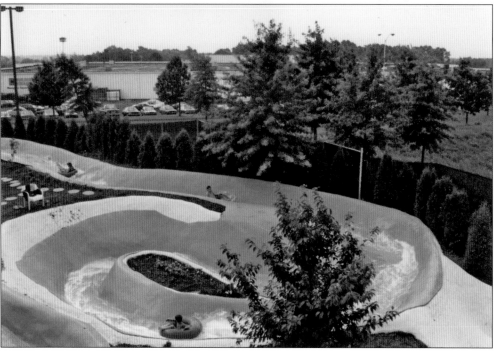

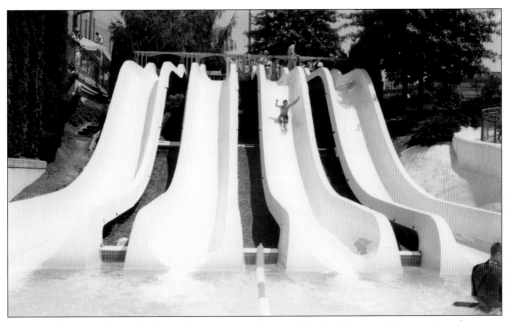

SLIPPERY SLOPES. These four body flumes, manufactured by Surf Coaster Corporation, feature a short drop followed by a longer and steeper drop over their 70-foot lengths. Because these four slides run side-by-side, they offer friends, families, and strangers the ability to race one another to the exit pool below. Like Big Slipper and Sesame Streak, the ride's 42-inch height requirement has made it an attraction that Sesame Place's bigger guests can enjoy.

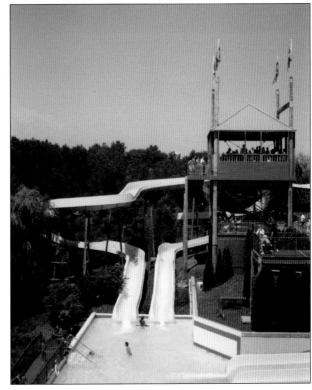

THE BIG SLIPPER. The Big Slipper is a body flume water slide manufactured by Surf Coaster. It features several twists and turns before exiting in a pool shared with Sesame Streak. Big Slipper opened at Sesame Place in 1985 and gave adults and bigger children a way to cool off at the park. Its addition highlighted the park's first shift toward adding water attractions.

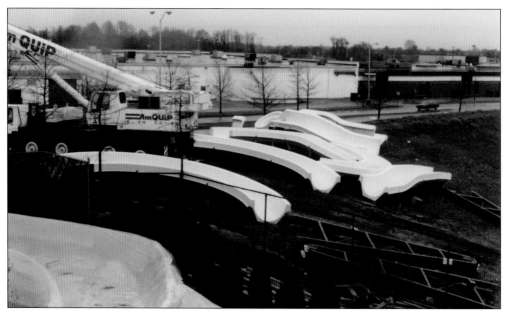

SESAME STREAK CONSTRUCTION. Large pieces of the Sesame Streak water slide are arranged on the ground just outside the edge of the park in this 1986 construction photograph. On this exciting ride, riders board a single or double tube and slide down the winding tubes to the bottom. Next to the pieces of the slide are the wooden supports. (Courtesy of Greg Hartley.)

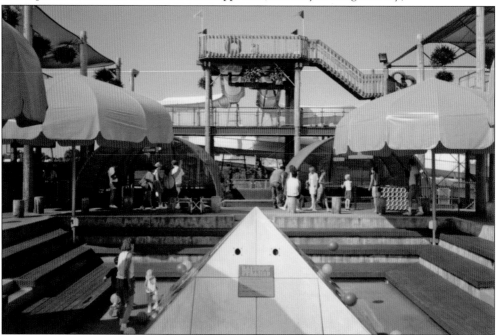

RAINBOW PYRAMID, SNUFFLEBALLS, AND SESAME STREAK. This 1991 photograph shows the great many layers of the park. Below, children float balls above the Rainbow Pyramid. At ground level, guests enter and exit the ball pits of Snuffleballs underneath the orange awnings. In the background, guests can rise up and then slide down to a pool below on the Sesame Streak tube slide. The park's many layers helped give it a sense of wonder and excitement.

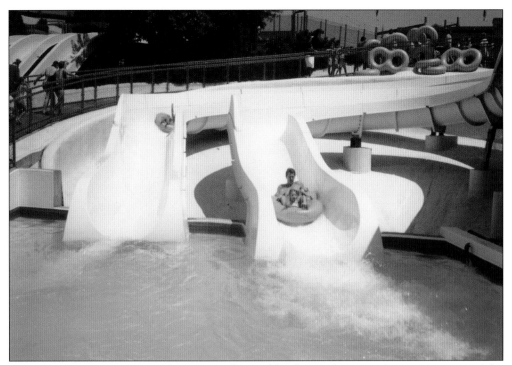

SESAME STREAK. Sesame Streak was manufactured by the Surf Coaster Corporation, one of the pioneering companies in the water slide manufacturing industry and one of the first to incorporate fiberglass slides made from molds in its designs. This three-story tube ride features tunnels with light holes, twists, turns, and drops before exiting into a pool. Guests may choose to ride either single or double tubes down the slides.

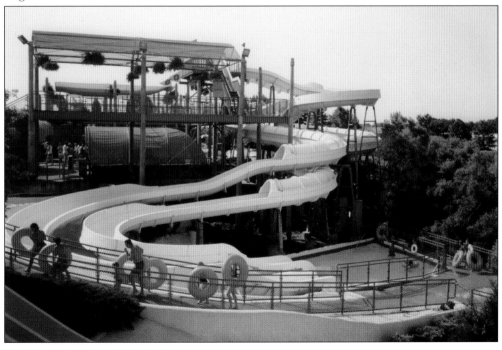

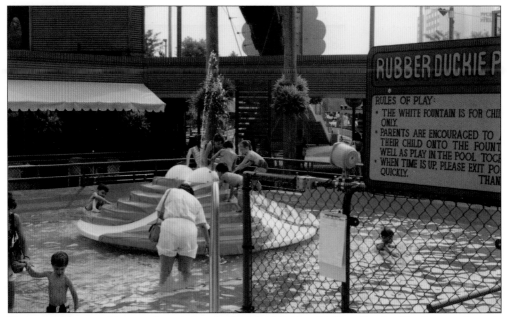

POND FOR RUBBER DUCKIE. Located under Big Bird Bridge, Rubber Duckie Pond went through a series of changes over the years. Originally, it was a gigantic water bed where kids could stomp around on the plastic surface and feel the waves wiggle under their feet. The merry-go-round fountain in the middle moved over to The Count's Fount in the early 1990s and was replaced by a slide and a statue of Bert and Ernie.

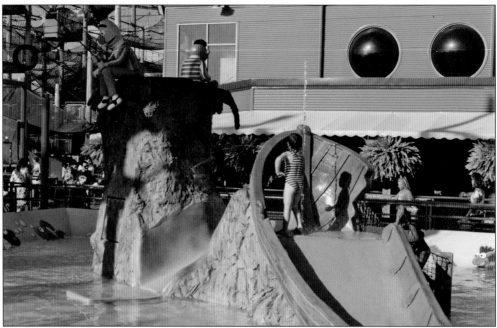

RUBBER DUCKIE POND. This third version of the Rubber Duckie Pond shows the themed faux rockwork, boat slide, and Bert and Ernie fishing atop the tallest rock. A second slide is in the middle of the island. The Bert and Ernie characters proved to not be the best fishermen, with both having caught only two gags: a boot and a tin can.

SESAME NEIGHBORHOOD.
At right are the steel foundations of what would become Sesame Neighborhood. Below is the completed area, which is a series of facades with some interior areas. This full-size version of Sesame Street allows children to see Big Bird's nest, go inside the Fix It Shop, sit on the steps of Ernie and Bert's apartment, and play hopscotch next to Hooper's Store. Sesame Neighborhood also has a firehouse complete with a vintage fire truck children can sit in. The fire truck has been a popular spot for guests to take photographs since the area opened in 1988. The area is also a popular spot for meet-and-greets with some of the *Sesame Street* characters. (Both, courtesy of Greg Hartley.)

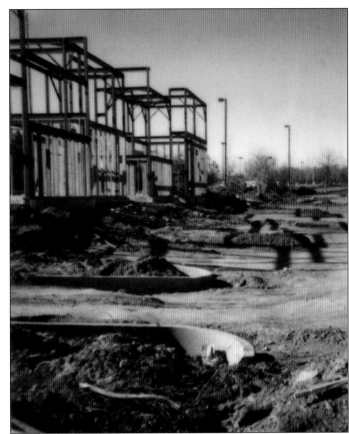

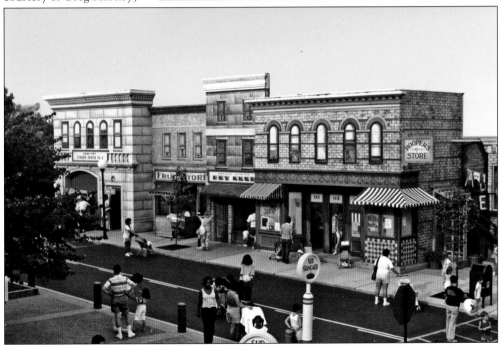

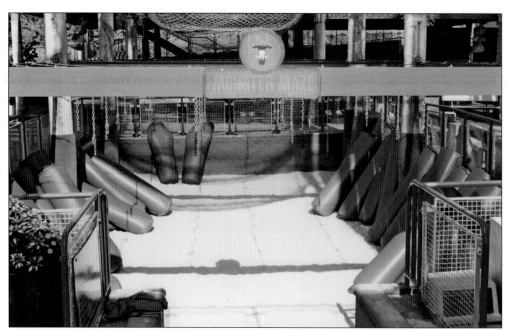

MONSTER MAZE. Monster Maze was a series of punching bags in a sandpit. Above, we see the bags lined up on the sides of the pit, ready for hanging. The original sign for the attraction featured Frazzle, an orange Muppet who definitely appears to be a monster. Below, we see eyes and horns added to the punching bags to give them a more monstrous appearance. Later known as simply the Monster Maze, the attraction would remain through the 2013 season.

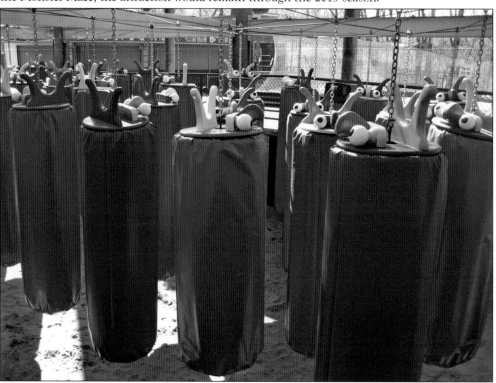

CHERYL HENSON VISITS SESAME NEIGHBORHOOD. Sesame Place president Bob Caruso and Cheryl Henson stand on the street in front of Mr. Macintosh's Fruit Store. Cheryl is one of Muppets creator Jim Henson's five children. Jim Henson was one of the creative minds behind Sesame Place, although his attention was divided among several other endeavors at the time, including *The Muppet Movie*.

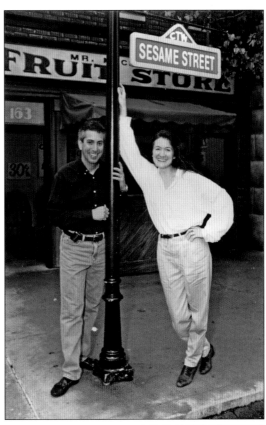

EXPO '90. Sesame Place was part of the International Garden and Greenery Exposition in Osaka, Japan. The massive Sesame Place pavilion was designed to promote the new Tokyo version of Sesame Place. The Expo '90 Sesame Place entertained visitors during the 183-day event featuring scaled-down versions of Sesame Neighborhood, The Count's Ballroom, Cookie Mountain, and other attractions. (Courtesy of Greg Hartley.)

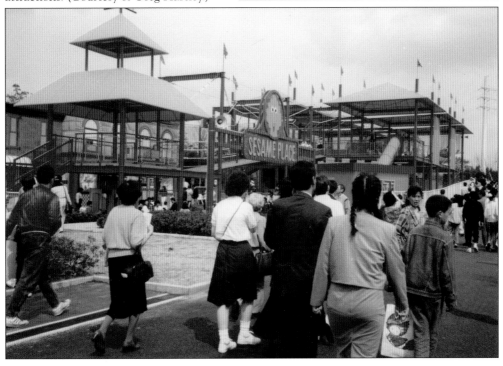

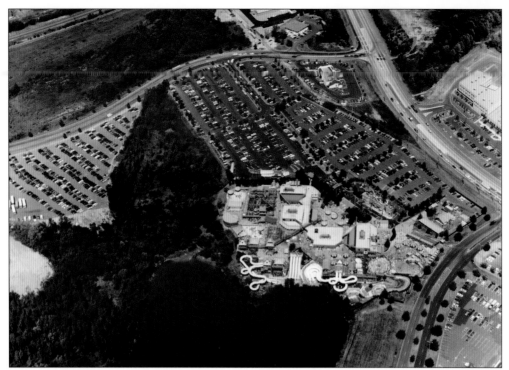

SPREADING AND FLOURISHING. The aerial photograph above shows the park in 1988. Below is a view from 1990. Big Bird Bridge can be seen in both photographs, and the entrance has been moved to the right. In 1990, the park had a huge expansion with the addition of Big Bird's Rambling River. This replaced a section of the parking lot. Later, the large plot of land across the street was paved to become the new parking lot.

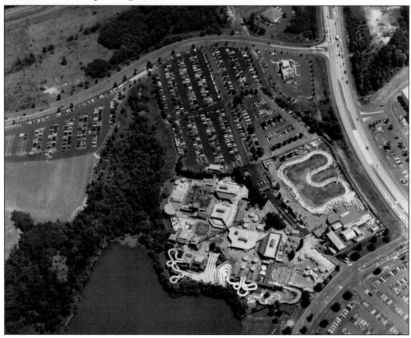

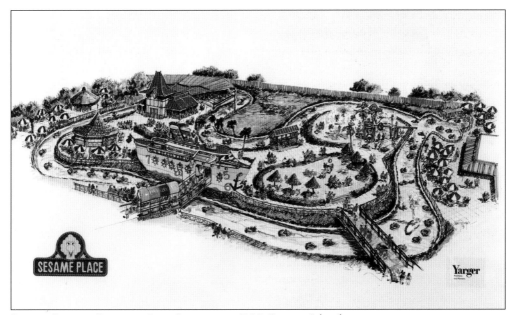

SESAME ISLAND CONCEPT ART. Opening in 1990, Sesame Island was an impressive expansion to the park. The entire island is located within the confines of the massive Big Bird's Rambling River. The entrance to the island is the gigantic Good Ship Sesame. From there, guests can visit Ernie's Waterworks, Grover's Island Grille, and the Paradise Theater. (Courtesy of Greg Hartley.)

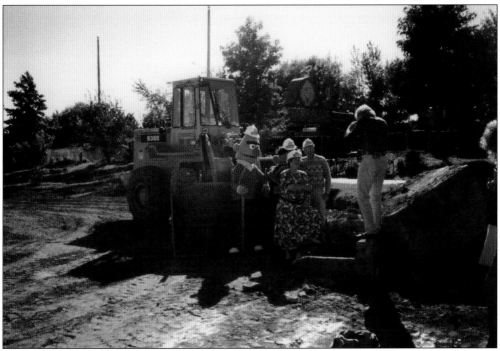

CONSTRUCTION OF THE RAMBLING RIVER. Bert and Ernie don hard hats and pose for photographs as construction is underway on Big Bird's Rambling River. The area had been used as the main parking lot for the park on opening day. Big Bird's Rambling River significantly expanded the park and changed the park's public perception as more of a water park.

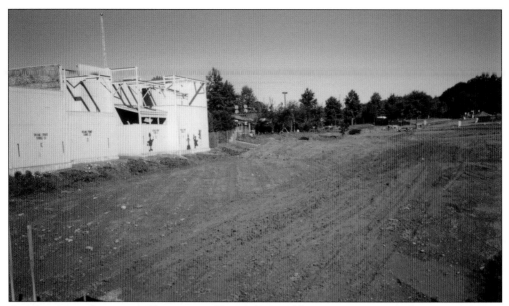

GROWING AND GROWING. The massive Big Bird's Rambling River was an ambitious expansion that required an amazing amount of construction. In addition to the expansion in Langhorne, the Sesame Place brand was also expanding overseas with the construction of Tokyo Sesame Place. The Japanese park was open from 1990 to 2006 and featured many of the same experiences as the Pennsylvania location.

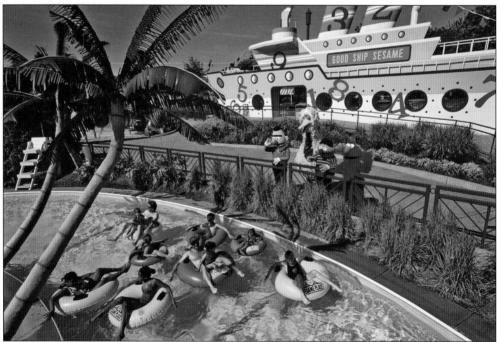

RAMBLING ALONG. Big Bird's Rambling River, which encircles Sesame Island, features two entrances and exits. At the yellow entrance, guests receive yellow tubes. At the blue entrance, guests receive blue tubes. Here, Bert, Ernie, Elmo, and Big Bird wave at guests enjoying their lazy river adventure near the Good Ship Sesame.

Big Bird's Rambling River. Here, guests are enjoying the cooling and relaxing ride of Big Bird's Rambling River during the 1991 season. The attraction, a lazy river–type water ride, opened in May 1990. The palm trees above feature coconuts that fill with water to dump on unsuspecting guests. The coconuts are one of several surprising obstacles along the course of the river.

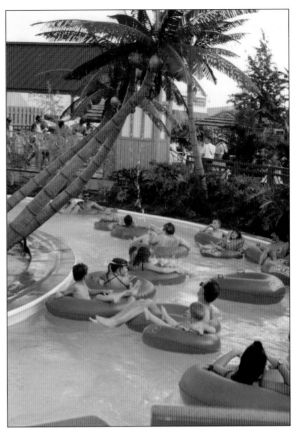

Sand Castle Beach. Sand Castle Beach is the pinnacle of sandboxes. Located on Sesame Island, this large plot of sand is surrounded by comfortable lawn chairs and provides a great place for parents to relax as kids dig around in the beach. In the distance one can see Trader Bert's Treasures, a souvenir shop that is stocked with bathing suits, water shoes, and sun block.

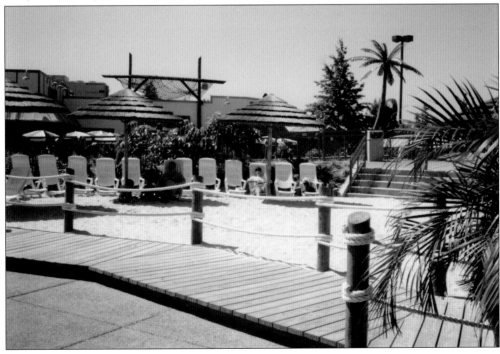

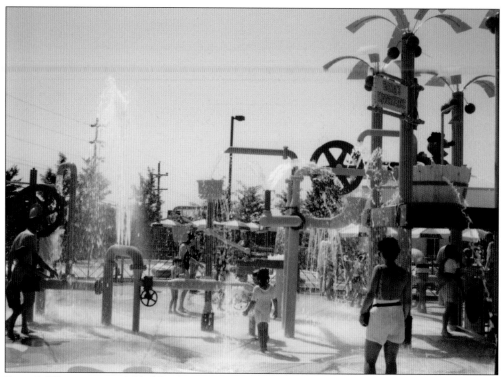

ERNIE'S WATERWORKS. Added for the 1990 season, this series of pipes, fountains, water wheels, and more features a fiberglass figure of Ernie taking a bath with his famous Rubber Duckie atop the structure. This themed figure, colorful structure, and interactive play elements showcase the newer design capabilities of the water park industry at the time. Compared to older installations such as The Count's Fount and Little Bird's Birdbath, these interactive areas were beyond thrilling.

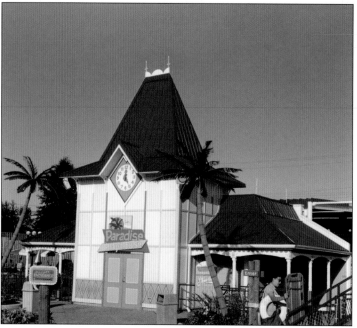

PARADISE PLAYHOUSE. Today it is known as Abby's Paradise Theater, but when the Sesame Island section of Sesame Place opened in 1991, this was Paradise Playhouse. In its opening year, Paradise Playhouse featured a show starring birds trained by Corey Schmidt. These birds would perform everything from singing to playing basketball. In 2012, the very popular show *Let's Play Together* opened, and a roof was added to the theater.

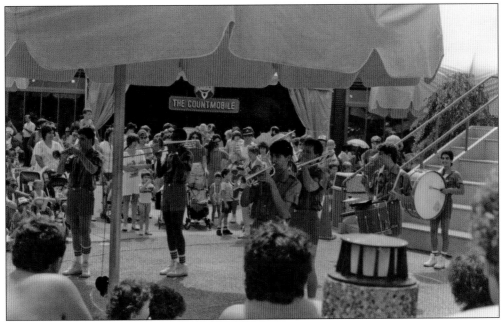

LIVE MUSIC. This 1987 photograph shows The Sesame Brass. This marching band first appeared in the park in 1985 and has had many different members over the years. In the background a sign can be seen for the Countmobile, a car from the 1985 film *Follow That Bird*, which was displayed at the park for many years. The Countmobile was a purple, antique-style car with bat-like wings and the license plate 12345678910.

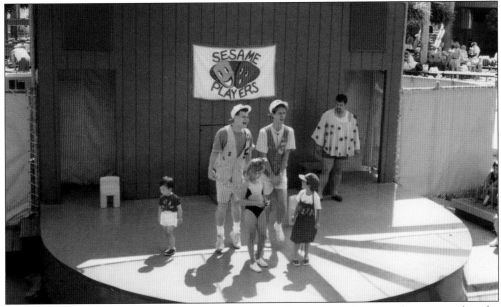

SESAME PLAYERS. The Sesame Players were a group of comedy performers who appeared at the Circle Theater, often on a rotating schedule with the animal show. The Sesame Players would often bring kids on stage to participate as part of a show that was fun and interactive. The shows were educational as well as entertaining, particularly the Sesame Players' *Environmental Tales* show. (Courtesy of Greg Hartley.)

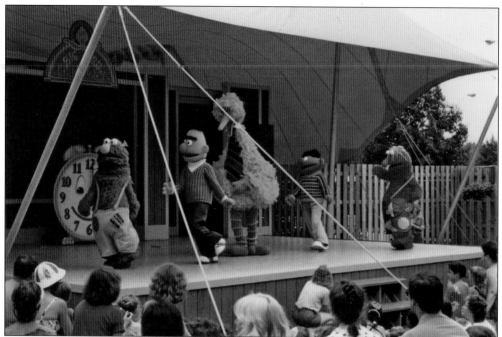

BIG BIRD AND COMPANY MUSICAL REVIEW. In 1989, this popular sing-along show opened in Big Bird Theater and featured many audience participation songs about laughter, letters, and counting. Jim Henson provided the voice of Ernie for this show, which ran until two years after his untimely death in 1990. This show also featured several other Muppet characters and stage props.

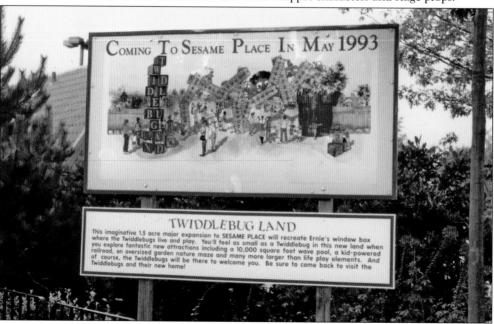

COMING SOON: TWIDDLEBUG LAND. The end of the 1992 season featured a promising future. This sign announced the 1.5-acre expansion of the park that added Twiddlebug Land. This land is based on the bugs that live in Ernie's windowsill on Sesame Street. The area features many giant-sized props to give kids the feeling of being shrunk down to the size of a Twiddlebug.

Four

1993–2005
New Lands, New Experiences

Sesame Place's important place in the local community was cemented in 1993, when the 145-foot Middletown Township water tower was painted as a billboard for the park. Drivers on Interstate 95 could now see giant images of Big Bird, Bert, Ernie, and Elmo advertising the park from the road.

That year also saw the addition of a new themed land, Twiddlebug Land, which would eventually house the impressive Sky Splash® family raft ride topped with a rubber duck so large one can see it from outside the park.

The park continued its focus on the addition of water rides but also added its first and only roller coaster, Super Grover's Vapor Trail®, in 1998, as well as several other dry flat rides in the early 2000s. These dry ride additions included Grover's World Twirl, a tea cup ride, and Big Bird's Balloon Race, a spinning balloon observation tower.

This 1993–2005 period was probably the time of greatest change in the park's history. Many opening day attractions, such as the Rainbow Pyramid, and many Sesame Studio elements would be retired during this era as the park's focus again changed from science discovery (1980–1984), to water park (1985–1992), to a mix of dry theme park rides and water park elements (1993–2005).

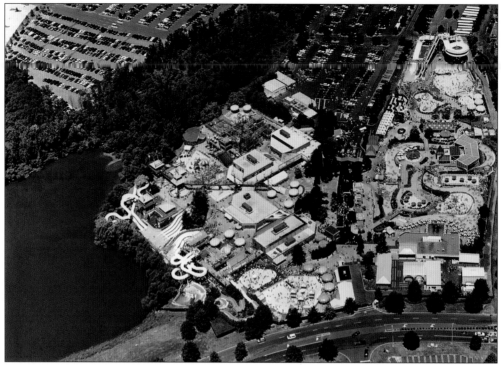

CHANGE AND EXPANSION. The mid-1990s were a unique time at Sesame Place. Many older attractions were still around, but so many new attractions had been added. Sesame Island and Twiddlebug Land were both open and thrilling guests. Meanwhile, Rainbow Pyramid and Bert's Balance Beams still had a few years left, and Big Bird Bridge was still welcoming park visitors. Compare this aerial image to the one on page 12.

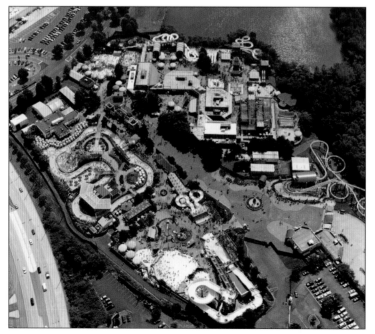

BIG BIRD'S–EYE VIEW OF A BIG PARK. In its first 20 years, Sesame Place experienced impressive growth, more than doubling in size. The road that separates the park in the middle was once where cars would drop off passengers. Everything to the left of that in this photograph was a large parking lot. In this image, one can see the iconic entrance to Big Bird Bridge still present even though the bridge was removed. (Courtesy of Greg Hartley.)

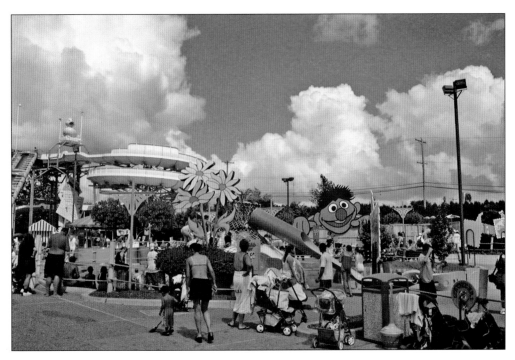

TWIDDLEBUG LAND. A 16-foot-high Ernie peers over the fence at Twiddlebug Land. This oversized land made guests feel the size of Twiddlebugs, the bugs that live inside Ernie's flower box. Located in this area is Sky Splash®, children's activities like the Silly Sand Slide and an oversized watering can shower, Mix 'n' Match Twiddle Tracks, and Slimey's Chutes water slides. Below is the Teeny Tiny Tidal Wave pool, perfect for the little ones. (Below, courtesy of Anthony and Nancy Mercaldo.)

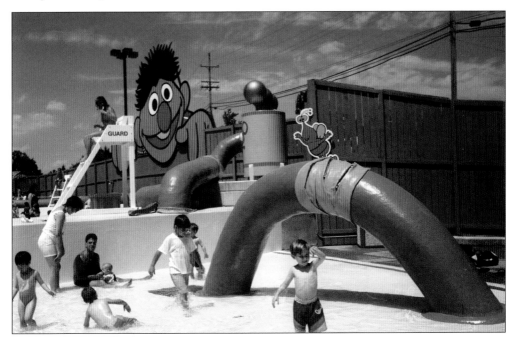

SPRUCING UP THE SIGN. In 1997, workers diligently apply some fresh coats of paint to the Sesame Place sign and archway. This double-sided sign was originally used at the Sesame Place location in Irving, Texas. Langhorne's original single-sided sign is currently located above the turnstiles at the park entrance. The multicolored circles, a Milton Glaser design, are affectionately called whirly-gigs.

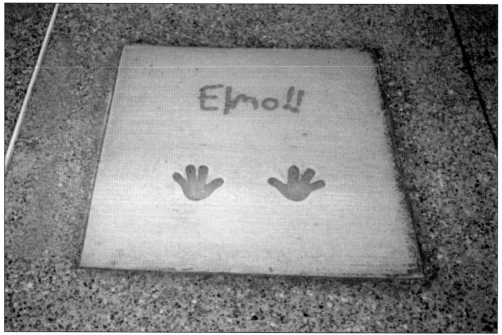

THE FORECOURT OF THE STARS. When Sesame Place relocated the park entrance from the eastern side of the park to the north, it created a large forecourt. Here, some of the famous stars of *Sesame Street* put their handprints and autographs in the cement. Elmo, Big Bird, and Cookie Monster left their mark in the ground much like John Wayne, Marilyn Monroe, and Shirley Temple have at TCL Chinese Theatre in Hollywood, California. (Courtesy of Greg Hartley.)

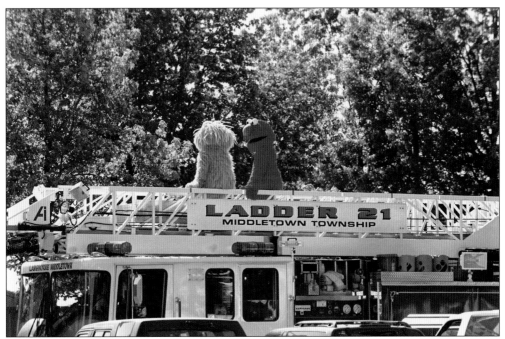

ZOE AND ELMO ON LADDER 21. An old Sesame Place tradition was to have a parade kick off the new season. Here we see Elmo and Zoe arrive by Langhorne-Middletown fire truck in 2002. Other characters would arrive in convertibles. This also exemplifies the great involvement of Sesame Place in its local community.

GORDON AND MARIA AT SESAME PLACE. *Sesame Street*'s Maria Figueroa-Rodriguez and Gordon Robinson, portrayed by actors Sonia Manzano (left) and Roscoe Orman (right), respectively, have been staples of television's *Sesame Street* for decades. Here, the duo visits the park during the 2004 opening day ceremonies and greets guests and fans of the show.

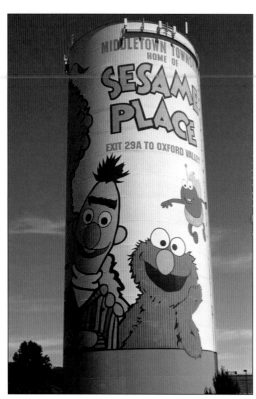

MIDDLETOWN TOWNSHIP GOES SESAME. At left is the original paint scheme of the Middletown Township Water Tower once it received its first coat of Sesame Place paint. Unique to this scheme are the short-lived dancing letters logo and the fact that it actually was paint. Below, in 2002, workers install nearly 20,000 feet of vinyl images of both *Sesame Street* characters and Sesame Place attractions.

GROVER CLOCK. This was one of the few remains of the Texas Sesame Place that was sent to Pennsylvania. Grover's eyes moved back and forth while the Oscar the Grouch pendulum swung back and forth below. The clock remains at the park outside the Monster Rock Theater, but the original Grover face has been updated with new imagery.

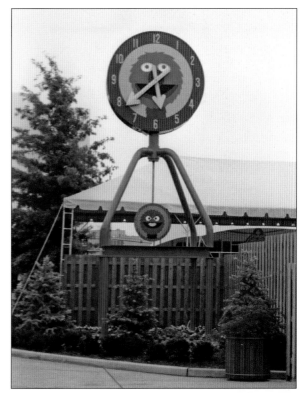

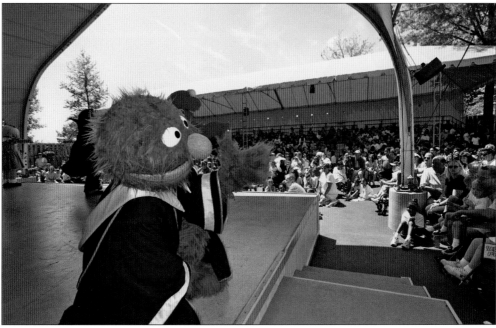

ENTERTAINING THE CROWDS. Grover takes to the stage to entertain the masses at Big Bird Theater (now Monster Rock Theater). Costumed character stage shows have been a part of Sesame Place's entertainment offerings since 1983, when a small stage show called *The Bert and Ernie Show* was performed on a small stage in front of Mr. Hooper's Emporium.

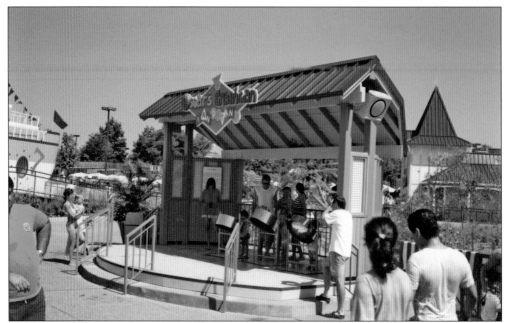

OSCAR'S TRASH CAN BANDSTAND. From the shores of Big Bird's Rambling River and near the Good Ship Sesame, both children and adults could make music on Oscar's steel drum trash cans. The sounds of the drums helped provide a tropical feel to the surrounding areas of Sesame Island and for guests floating by on the river.

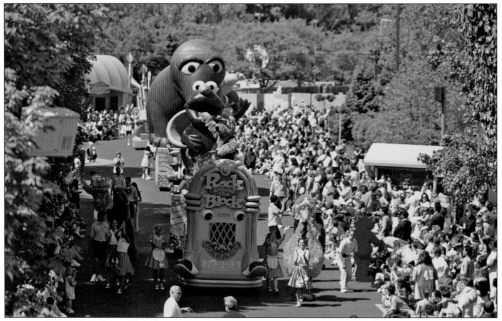

JACKMAN WOLF LEADS THE PARADE. *The Rock Around the Block® Parade* delighted families at Sesame Place for over a decade. The parade featured large floats, gigantic character balloons, and many hit songs performed by the *Sesame Street* characters. The first float of the parade was a giant jukebox with Jackman Wolf riding on top. Jackman Wolf was a *Sesame Street* character parody of famous disc jockey Wolfman Jack.

ELMO'S WORLD LIVE. *Elmo's World Live!* was one of the longest-running stage shows at Sesame Place. First opening in 2001, the show featured Elmo wanting to learn all about dance from his television and his friend Mr. Noodle. This version of the show was later replaced with a show where Elmo wanted to know about fish like his pet goldfish, Dorothy. The theater also hosted Halloween and Christmas versions of the show.

BIG BIRD BOOGIE. Big Bird watches his friends dancing on the stage as part of *Big Bird's Beach Party. Sesame Street*'s resident ballerina, Zoe, leads a group of less graceful Muppets, including Telly, Bert, and Ernie. The show played at Sesame Place from 2004 until 2009 and had also played at SeaWorld San Antonio, Texas.

SUPER GROVER'S VAPOR TRAIL®. In 1998, Sesame Place received its first roller coaster, Super Grover's Vapor Trail®. Themed to Grover's heroic alter ego, the ride includes a 56-foot drop and over 1,300 feet of track. Along with the delighted screams of passengers, the coaster has sound clips of Grover as he takes riders on a fast-paced mission into outer space and back. The coaster, built by Vekoma, has a top speed of 27 miles per hour and was one of the first dry ride additions to the park after years of water park growth.

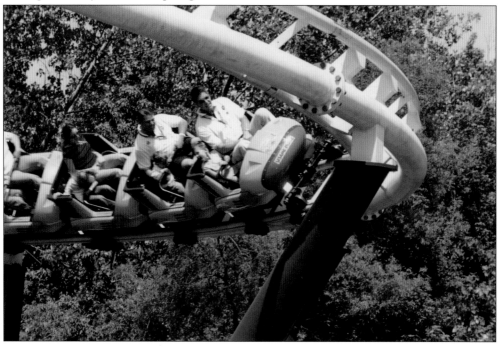

SESAME STREET BALLOONS. The 2000s saw a return of the classic Milton Glaser Sesame Place logo and the classic yellow polo team member uniform of the 1980s and early 1990s. Here, this team member carries a large bunch of bright and colorful character balloons to sell in the entry plaza of the park.

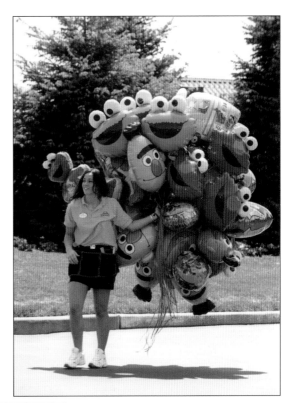

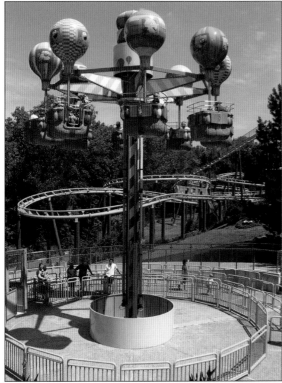

BIG BIRD'S BALLOON RACE. In 2002, Sesame Place added Big Bird's Balloon Race, a Samba balloon model dry ride from Italian manufacturer Zamperla. Guests can spin the gondola as it rises to a height of 40 feet. In 2014, the ride would be re-themed and renamed Flying Cookie Jars when it became a part of Cookie's Monster Land. (Courtesy of Mark Rosenzweig.)

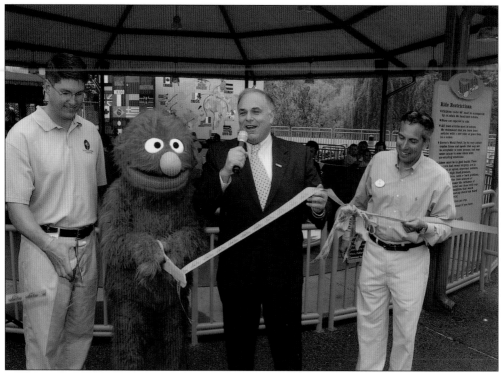

GROVER'S WORLD TWIRL. Above, Pennsylvania governor Ed Rendell takes part in the 2002 ribbon cutting to open the Zamperla spinning teacup ride named Grover's World Twirl. The attraction was based on the Global Grover segment from *Sesame Street*. Each cup featured a painting of one of the Sesame Place characters in traditional garb from various countries, below. With the opening of Cookie's Monster Land, the ride was renamed Monster Mix-up and now has a disco theme.

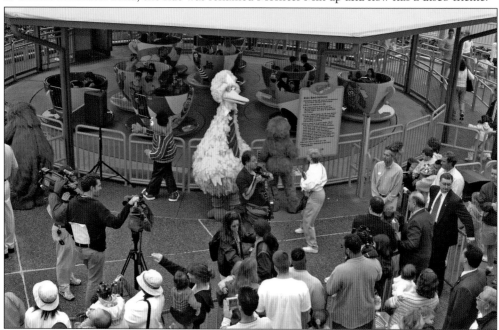

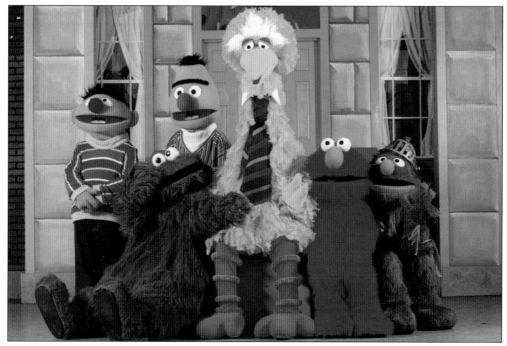

CAST OF CHARACTERS. The cast of Sesame Place's furry characters grew and grew over the years. Their addition was a result of the suggestions of team members, including Jim Henson's son Brian, who worked at the park in the early 1980s. Here, Grover is pictured wearing his Super Grover helmet and cape.

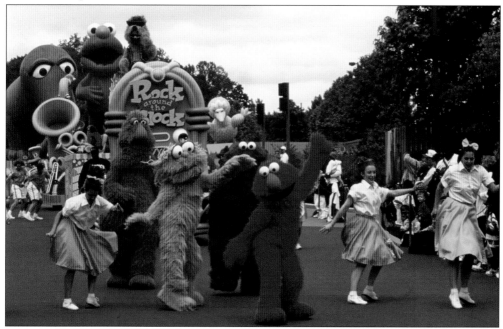

ROCKIN' AROUND THE BLOCK. After its debut in 1997, *The Rock Around the Block® Parade* would shake, rattle, and roll through Sesame Neighborhood until the end of the 2010 season. Giant balloons, dancers, musicians, and *Sesame Street* characters helped make this parade a long-lasting hit.

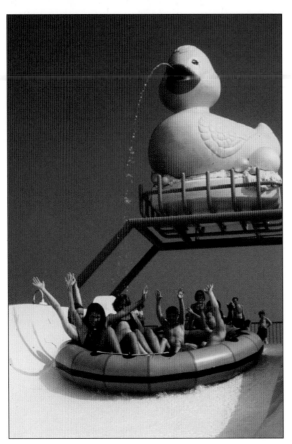

SKY SPLASH®. Visible from far outside the park with its large 8-foot-tall Rubber Duckie atop it, Sky Splash® was Sesame Place's 1995 addition to Twiddlebug Land. This family raft ride allows families to ride and slide down drops and turns together. The ride is over six stories tall.

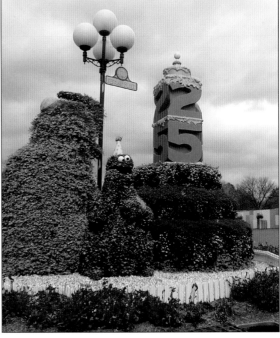

25TH BIRTHDAY. Sesame Place's central plaza always features great character topiaries. Here, Snuffy and Cookie Monster topiaries are featured next to a large cake topiary sporting a 25 to help celebrate the park's 25th birthday in 2005.

Five

2006 AND BEYOND
A SUNNY FUTURE

During the mid-to-late 1990s, the popularity of Elmo skyrocketed worldwide. With his own segment on *Sesame Street* called Elmo's World, Elmo earned a live show based on that segment, which would later be complemented with a whole new land at Sesame Place. Elmo's World would open at the park in 2006; it replaced some of the older water attractions such as Bert's Balance Beams as well as The Count's Ballroom. The ball crawl that had once been so unique and popular had now become commonplace at fast food restaurants and mall play areas around the country. Sesame Place replaced these older attractions with more traditional amusement and theme park rides with an Elmo's World theme.

During this era, two other classic water attractions, The Count's Fount and Little Bird's Birdbath, would be replaced with the larger and much more modern The Count's Splash Castle in 2009.

Parks around the country began developing both Halloween and Christmas events to help extend their seasons and celebrate the holidays with great events for guests. In 1997, Sesame Place introduced *The Count's Halloween Spooktacular*. This Halloween event proved so popular that a Christmas event, *A Very Furry Christmas*, was developed as well and debuted in 2011. These two events helped stretch Sesame Place's operating season from May all the way through the end of December, giving guests more time than ever before to enjoy the fun of the park.

In 2014, the park bid farewell to nearly all of the remaining opening day attractions from 1980, including the iconic Nets and Climbs, to make room for the monstrously exciting new land appropriately named Cookie's Monster Land. The lone surviving opening day attraction is Snuffy's Slides, which as of 2015 is still in operation.

As Sesame Place celebrates its 35th birthday in 2015, the park continues to grow and evolve in the same way that the television series has evolved and adapted to its ever-changing audience of children. If time has proven anything, it is that on both *Sesame Street* and at Sesame Place, it is always going to be a sunny day.

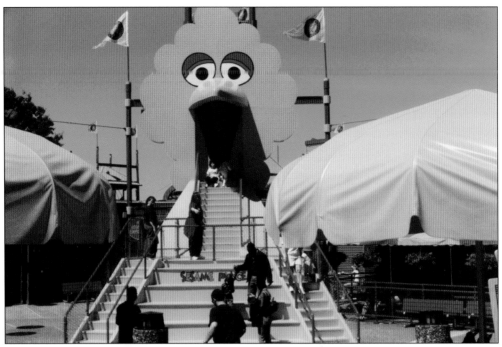

BIG BIRD ICON. The Big Bird Bridge's iconic entryway lasted even when the suspension bridge was removed. Visible on the steps is the short-lived dancing letters logo for the park that was used in the mid-to-late 1990s.

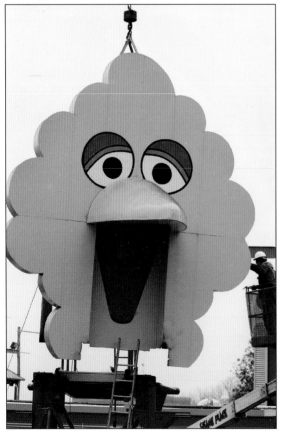

CHANGING TIMES. After serving as a park icon for 27 years, the Big Bird Bridge head was removed to make way for the addition of the Sunny Day Carousel. The head once marked the entry of the park, then its center. The look was identical to that of the logo.

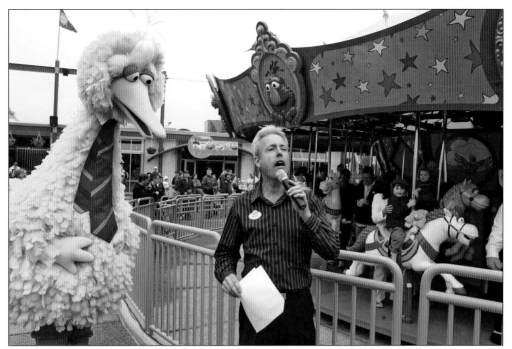

SUNNY DAY CAROUSEL. Big Bird officiates the very first ride on the Sunny Day Carousel. The carousel was designed with Muppet horses that bring up memories of Marshal Grover's Fred the Wonder Horse in the classic *Sesame Street* sketches. Calliope versions of songs such as "Elmo's World" and "Mahna Mahna" play as the ride spins.

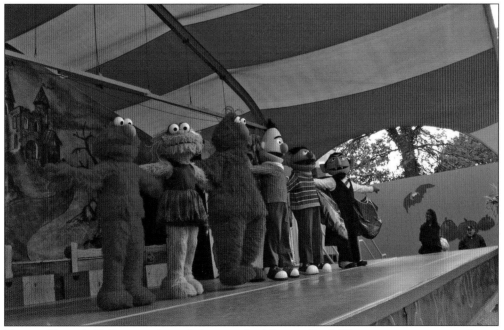

TAKE A BOW. A Halloween-themed show at the Monster Rock Theater comes to an end, and the cast of *Sesame Street* characters takes a bow. While moving mouths are a new feature at the Disney Parks, the characters at Sesame Place have always had them.

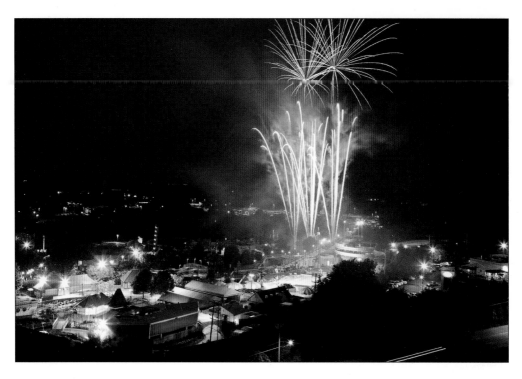

SUMMER NIGHTS SPARKLE. All the lights in the park shine brightly as fireworks explode in the sky. The fireworks were launched from the VIP parking lot and could be seen for miles away. The Memorial Day 2007 sparkling display was the first of many at the park.

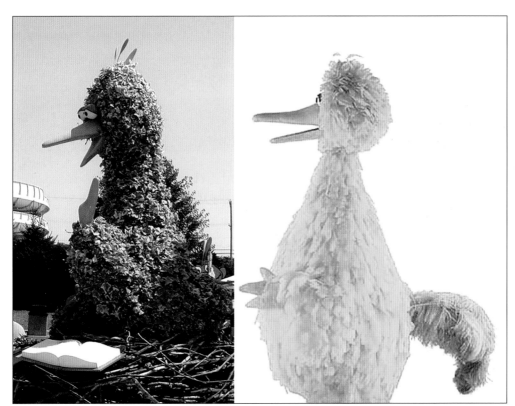

BIG BIRD TOPIARY. The character topiaries in the main entry plaza and throughout the rest of the park are constantly taken care of by the park's horticulture team to ensure that they look just like the characters they are supposed to.

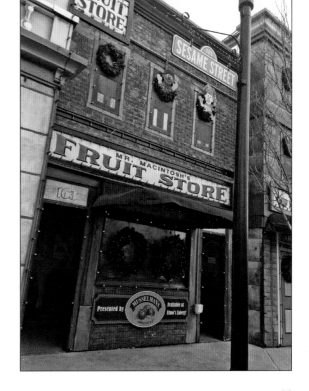

MR. MACINTOSH'S FRUIT STORE. Here we see Mr. Macintosh's Fruit Store decked out for the Christmas season. The attraction was added to Sesame Place in 1988 with the opening of Sesame Neighborhood. No fruit is actually sold here; instead, children can pretend and play with the fruit scale and cash register.

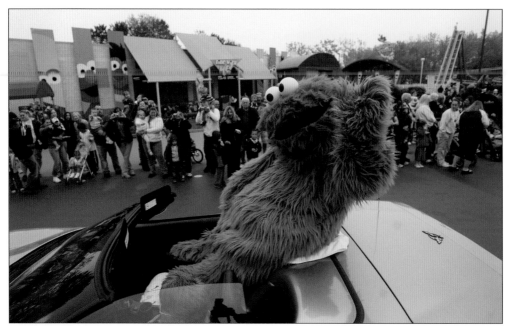

COOKIE MONSTER ARRIVES IN STYLE. A convertible seems like a smart choice for Cookie Monster, who famously ate the roof of Gordon's car in the 1985 *Sesame Street* film *Follow That Bird*. Cookie Monster rides through the park in this photograph of the 2008 opening day parade.

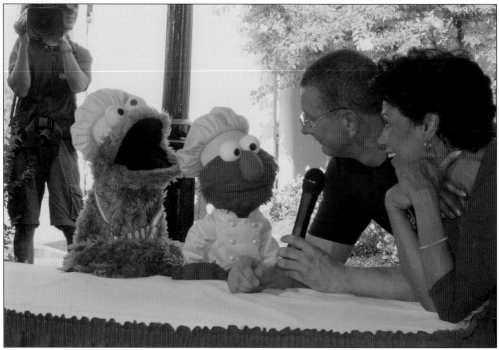

B FOR BIRTHDAY. In 2009, for the 40th birthday of *Sesame Street*, Sesame Place played host to the television show *Dinner: Impossible*. Elmo and Cookie Monster appeared with host Robert Irvine and *Sesame Street* star Sonia Manzano as they helped the park cater a park event featuring only foods that started with the letter "B."

ARTIST AT WORK. A young artist works on caricatures near Sunny Day Carousel. This area also has stations where children can get their faces painted or their hair wrapped. In the background is the souvenir store Oscar's Garage and some of the old cars parked outside the store for photo opportunities.

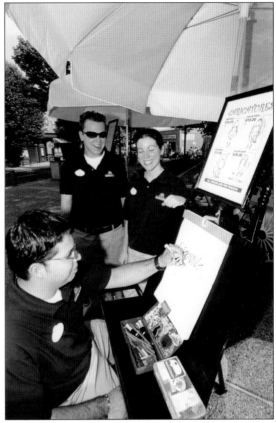

DINE WITH ME! A performer from the parade jumps rope as parade onlookers watch the entertainment. In the background is the park's Dine With Me! location where guests can eat breakfast, lunch, or dinner with their favorite *Sesame Street* characters.

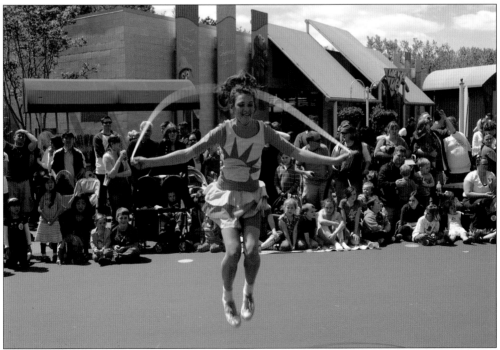

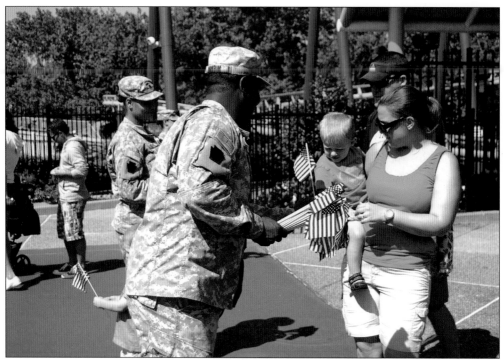

HERE'S TO THE HEROES. A longtime Busch Entertainment and SeaWorld Parks & Entertainment™ tradition is to honor America's heroes and veterans. Above, at the front of the park, US Army veterans gave each child entering the park an American flag. Below, the veterans present at the park pose for a photograph in front of the "Here's to the Heroes" banner.

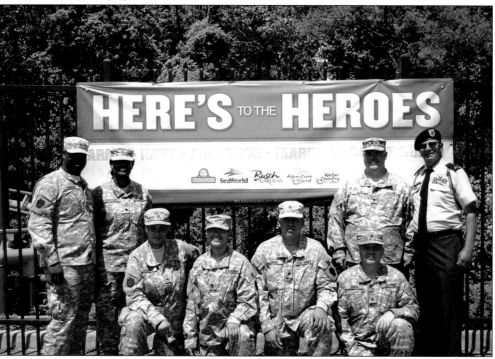

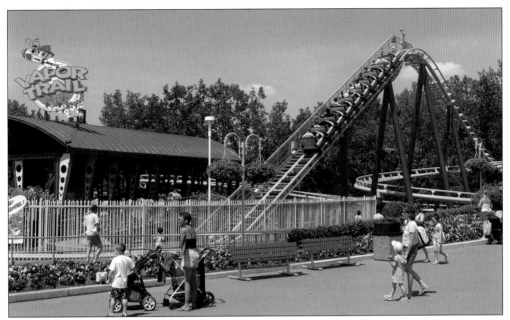

NEW PAINT ON SUPER GROVER'S VAPOR TRAIL®. Super Grover's Vapor Trail® roller coaster received a brand-new light blue paint scheme in 2006. This popular attraction greets guests right as they walk into the park. With an age requirement of only three years old if the child is accompanied by an adult, this is the first big roller coaster ride for many children who visit the park.

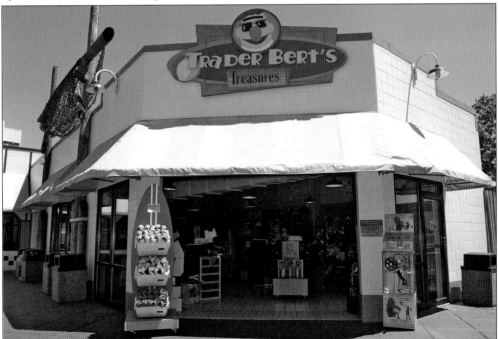

TRADER BERT'S TREASURES. Trader Bert's Treasures has everything a Sesame Place guest might need to get through a fun and exciting day at the park. In addition to great souvenirs like *Sesame Street* plush characters, this shop also sells the necessary water park essentials like sunblock, sunglasses, beach towels, and more. Trader Bert's, as it is often called, is tropically themed.

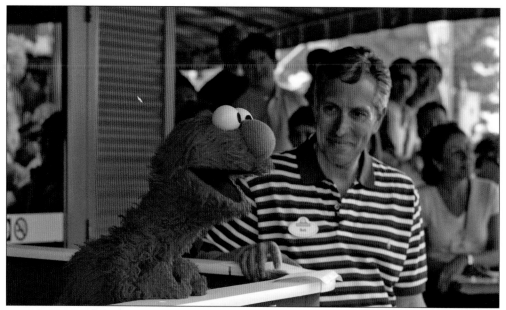

ELMO VISITS ELMO'S WORLD. Here we see the familiar television-sized Elmo puppet standing next to Sesame Place president Bob Caruso. Elmo was present this day in 2006 to celebrate the grand opening of Elmo's World. The new land featured many new rides and experiences and gave the popular red monster a much larger presence at the park.

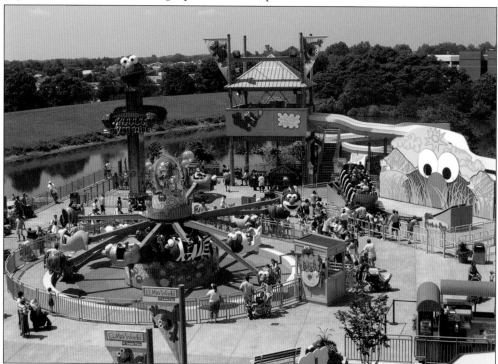

ELMO'S WORLD OVERVIEW. This aerial view of the new-for-2006 Elmo's World expansion shows the many great new rides it brought along with it. These new rides included Flyin' Fish (front left), Blast Off (back left), and Peek-A-Bug (right). (Courtesy of Mark Rosenzweig.)

BLAST OFF. On this family-friendly drop tower ride, children and adults board a UFO and bounce up and down to Planet Elmo. As the UFO gondola bounces, so do the riders' stomachs, providing a fun free-fall sensation for those on board.

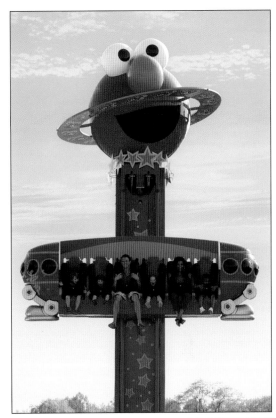

FLYIN' FISH. Flyin' Fish is a Dumbo-like ride that features a number of Elmo-faced gondolas that are different types of fish. There is a knight fish, a zebra fish, a dogfish, a clownfish, and more. Riders can raise or lower their fish into the air.

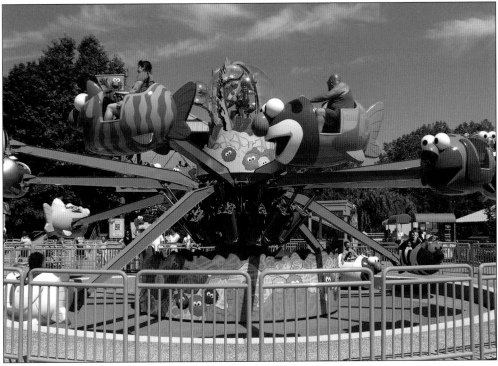

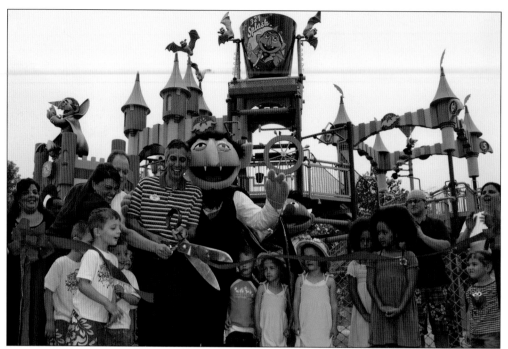

THE COUNT'S SPLASH CASTLE. In 2009, The Count's Fount and Little Bird's Birdbath were replaced by the multilevel The Count's Splash Castle. The attraction boasts over 90 play elements, but the centerpiece of it all is a 1,000-gallon bucket that tips over frequently, splashing all below. The Count's Splash Castle also features the voice of Count von Count, who warns that the eight-foot-tall bucket is tipping with, of course, a countdown.

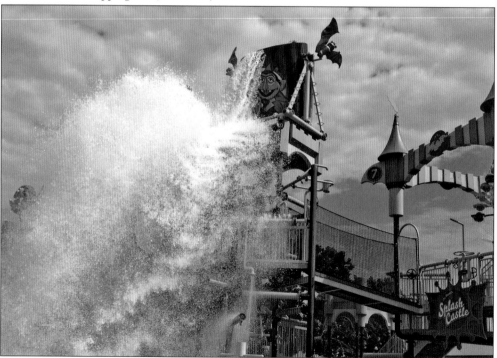

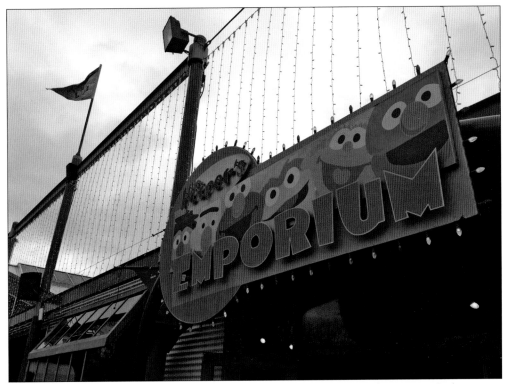

MR. HOOPER'S EMPORIUM. Mr. Hooper's Emporium has been the park's main gift shop since opening day in 1980. Named after the beloved Mr. Hooper character and his Mr. Hooper's Store from television, guests can find all their Sesame Place souvenirs inside. Above is the marquee to the store, decked out with Christmas lights for A *Very Furry Christmas.* Below is a photograph of the inside of the store and its many gifts. The plush characters overhead are on a carousel that takes them around the store and up above into the skylight.

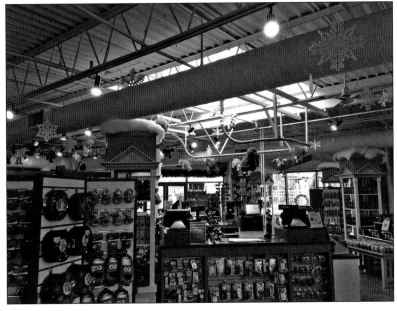

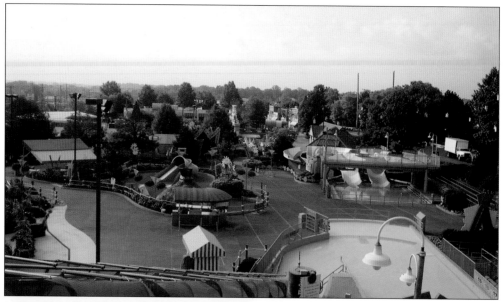

TWIDDLEBUG LAND FROM SKY SPLASH®. This photograph, taken from the Sky Splash® attraction, shows a great overview of the Twiddlebug Land area. To the right are the Slimey's Chutes slides, which were added to the park in 1996. Everything in this part of the park is oversized to give the illusion that the guests themselves are experiencing the world as the Twiddlebugs do.

NEW CHARACTERS, NEW BALLOONS, NEW COSTUMES. The ever-evolving world of *Sesame Street* and Sesame Place is evident here; this balloon attendant is wearing a new uniform costume and is carrying balloons featuring one of the newest *Sesame Street* residents, Abby Cadabby. One can compare this image to the one on page 67.

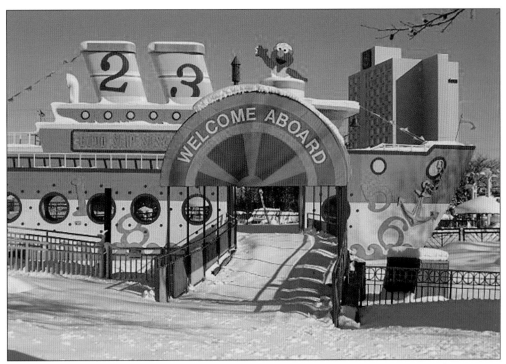

GOOD SHIP SESAME. Located right alongside Big Bird's Rambling River, the Good Ship Sesame has been a popular spot for guests to photograph for decades. Above, the northeastern winters are no stranger to Sesame Place during the off-season. Below, the summers offer completely opposite kinds of weather. Beautiful floral arrangements by the Sesame Place horticulture team like the ones pictured here can be found throughout the park.

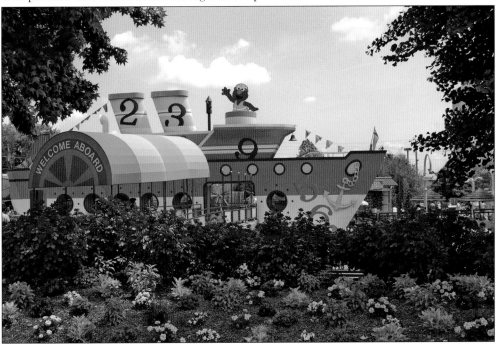

ELMO'S CLOUD CHASER. The closing of Rubber Duckie Pond made way for a 2011 addition to the Elmo's World section of the park. Elmo's Cloud Chaser is a whimsical swing ride. The ride's carousel spins and tilts, making it a thrill for children and adults. Cartoons that adorn the attraction show birds, balloons, and helicopters, and the entire ride is topped by an airplane with Elmo's face.

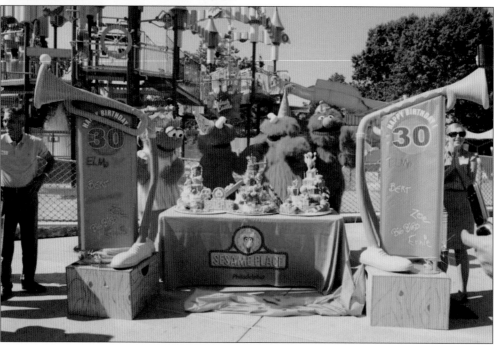

30 YEARS YOUNG. In 2010, the park reached another milestone. It was Sesame Place's 30th birthday, and Cookie Monster, Elmo, Zoe, and Grover led guests in the singing of "Happy Birthday." The celebration also featured three amazing cakes with miniature icing creations of many of the park's icons and rides, including Grover's Vapor Trail®, Sky Splash®, and Peek-A-Bug.

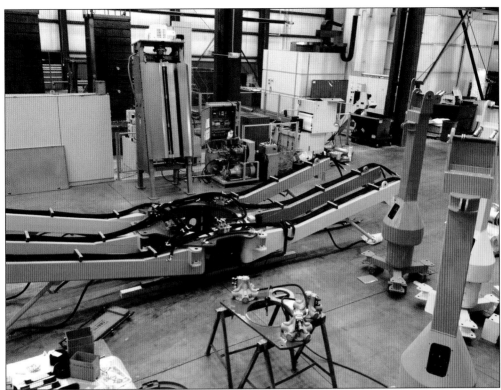

HONKER DINGER RESTORATION.
From 1979 to 2013, the Honker
Dinger Derby thrilled guests under
the name Sandstorm at Busch
Gardens in Tampa, Florida. When
the ride was removed, it was fully
restored and repainted before arriving
at its new home in Langhorne,
Pennsylvania. It is a Tivoli Orbitor
model ride and was replaced at
Busch Gardens by Falcon's Fury®.

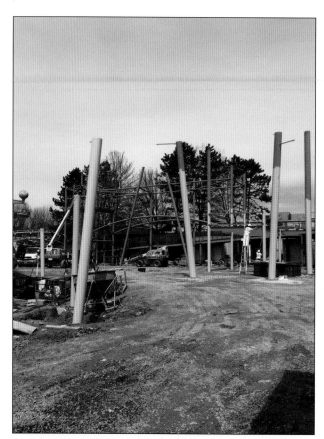

COOKIE'S MONSTER LAND. At left, construction crews are hard at work creating a new land full of rides and fun. Below is the finished Cookie's Monster Land with seven new rides and experiences. The entrance is marked by a gigantic cookie jar. Also visible here are Honker and Dinger meeting with guests.

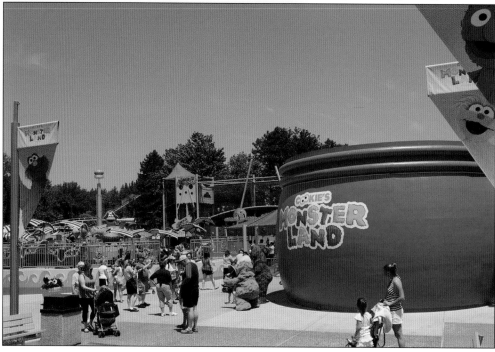

COOKIE'S MONSTER LAND OVERVIEW.
Not all of the attractions in Cookie's
Monster Land are pictured here,
but from left to right are Captain
Cookie's High "C's" Adventure,
123 Smile with Me!®, the Honker
Dinger Derby, and Oscar's Rotten
Rusty Rockets. 123 Smile with
Me!® is a popular character meet-
and-greet location for guests.

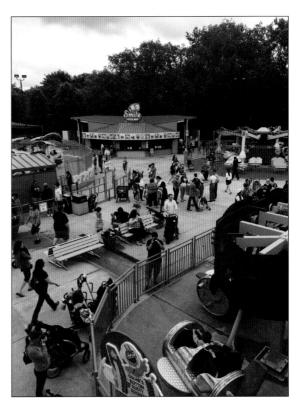

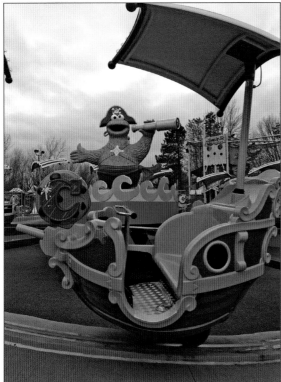

**CAPTAIN COOKIE'S HIGH "C'S"
ADVENTURE.** On this ride, guests
board two-seat yellow pirate ships
that spin around a statue of Cookie
Monster decked out in his finest pirate
garb. These yellow pirate ships hop
up and down as though on waves as
they spin around the centerpiece.

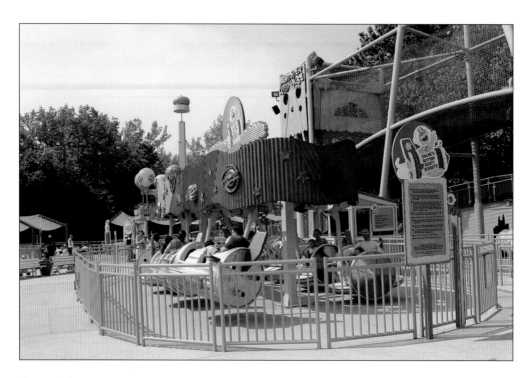

OSCAR'S ROTTEN RUSTY ROCKETS AND MONSTER CLUBHOUSE. Above, Oscar's Rotten Rusty Rockets are a suspended whip-style ride manufactured by Zamperla. The rockets, which are garbage can rockets with tin can thrusters, swing outward when they hit the turns. Below, the Monster Clubhouse replaced the park's long-lived Nets and Climbs attraction.

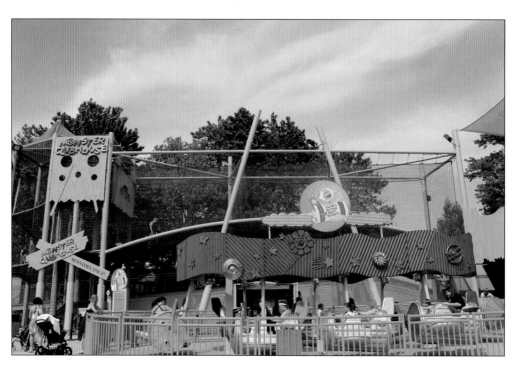

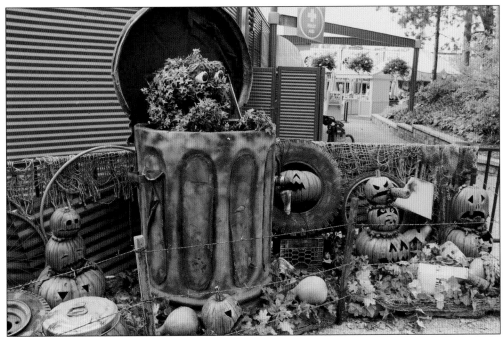

A GROUCH'S HALLOWEEN. The Count's Halloween Spooktacular has been entertaining the families who visit Sesame Place for many years. In addition to colorful Halloween displays, like this one of Oscar the Grouch and his junkyard of pumpkins, the park has special themed mazes, Halloween shows, and Trick-or-Treating spots where kids can pick up special snacks.

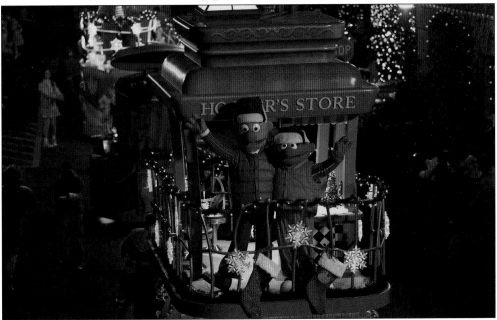

CHRISTMAS PARADE. In 2011, the park debuted *A Very Furry Christmas* complete with a Christmas version of the new *Neighborhood Street Party Parade*. Additions to the parade for the event include Christmas music and characters wearing festive winter clothing. At night, the parade floats illuminate, thanks to countless twinkling lights.

A Very Furry Archway. During the *A Very Furry Christmas* event, the Sesame Place entry arch receives a holiday overlay with Christmas graphics covering the Big Bird logo and garland adorning the rest of the sign. Christmas and holiday additions like this can be found all over the park for this special event.

Sesame Place Furry Express. *A Very Furry Christmas* features a trackless train that takes guests on a tour of the Twiddlebugs' Gingerbread Cookie Factory. This uniquely narrated ride utilizes much of the space in Twiddlebug Land, providing a special seasonal experience. The ride also features music, sound effects, and the aroma of gingerbread!

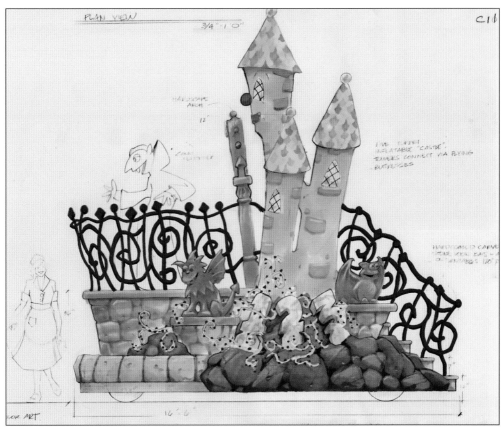

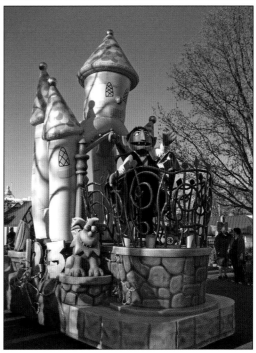

THE COUNT'S CASTLE FLOAT. Above, the concept artwork for the Count's Castle Float shows the original plans for the float before it was built. At right, the float that was actually built for the *Neighborhood Street Party Parade* closely resembles the original concept art, showcasing the magic of concept to reality.

NEW CHARACTERS WELCOME. After the *Rock Around the Block® Parade* was retired in 2010, the new *Neighborhood Street Party Parade* introduced in 2011 brought with it many new floats and much excitement. While Abby Cadabby and Murray are newer additions to the *Sesame Street* television cast, they all found their way to Sesame Place shortly after their television debuts.

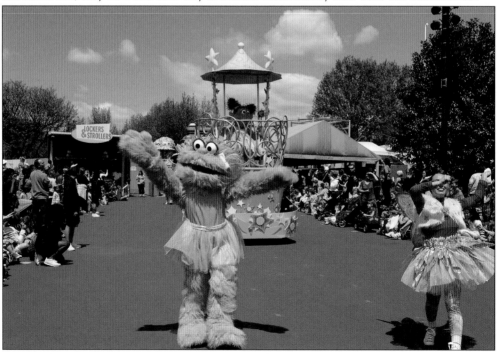

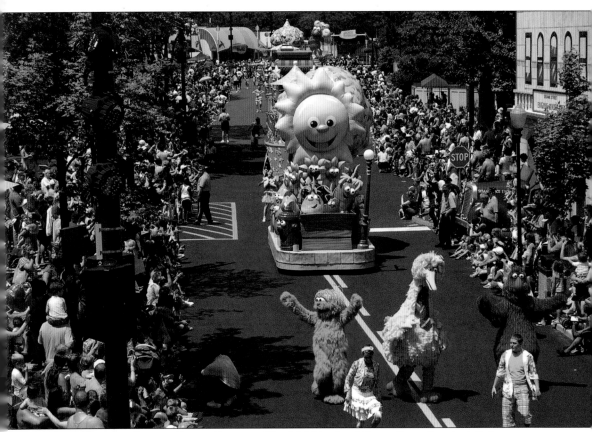

NEIGHBORHOOD STREET PARTY PARADE. The *Neighborhood Street Party Parade* delights guests daily at Sesame Place. The parade features 13 floats, all of which are also used at night and for the Halloween and Christmas versions of the parade.

DISCOVER THOUSANDS OF LOCAL HISTORY BOOKS FEATURING MILLIONS OF VINTAGE IMAGES

Arcadia Publishing, the leading local history publisher in the United States, is committed to making history accessible and meaningful through publishing books that celebrate and preserve the heritage of America's people and places.

Find more books like this at
www.arcadiapublishing.com

Search for your hometown history, your old
stomping grounds, and even your favorite sports team.